CONTENTS

INTRODUCTION ... 6
TIMELINE ... 8
GUAN DAOSHENG (1262-1319) 11
CHRISTINE DE PIZAN (1364-1430) 13
LAVINIA FONTANA (1552-1614) 15
ELISABETTA SIRANI (1638-1665) 17
ÉLISABETH LOUISE VIGÉE LE BRUN (1755-1842) 19
JULIA MARGARET CAMERON (1815-1879) 21
ROSA BONHEUR (1822-1899) 23
HARRIET POWERS (1837-1910) 25
MARY EDMONIA LEWIS (1844-1907) 27
MARY CASSATT (1844-1926) 29
NAMPEYO (1859-1942) 31
BEATRIX POTTER (1866-1943) 33
ELEMENTS AND PRINCIPLES OF ART AND DESIGN 34
JEANNE PAQUIN (1869-1936) 37
JULIA MORGAN (1872-1957) 39
TARSILA DO AMARAL (1886-1973) 41
GEORGIA O'KEEFFE (1887-1986) 43
HANNAH HÖCH (1889-1978) 45
ALMA THOMAS (1891-1978) 47
AUGUSTA SAVAGE (1892-1962) 49
DOROTHEA LANGE (1895-1965) 51
DOROTHY LIEBES (1897-1972) 53
TAMARA DE LEMPICKA (1898-1980) 55
LOUISE NEVELSON (1899-1988) 57
STATISTICS IN ART 58
BELLE KOGAN (1902-2000) 61
LOLA ÁLVAREZ BRAVO (1903-1993) 63
LOÏS MAILOU JONES (1905-1998) 65
LEE MILLER (1907-1977) 67

FRIDA KAHLO (1907-1954) . 69
CIPE PINELES (1908-1991) . 71
MARY BLAIR (1911-1978) . 73
THELMA JOHNSON STREAT (1911-1959) 75
LOUISE BOURGEOIS (1911-2010) . 77
RAY EAMES (1912-1988) . 79
MÉRET OPPENHEIM (1913-1985) . 81
AMRITA SHER-GIL (1913-1941) . 83
ELIZABETH CATLETT (1915-2012) . 85
ART TOOLS . 86
RUTH ASAWA (1926-2013) . 89
NORMA SKLAREK (1926-2012) . 91
YAYOI KUSAMA (1929-) . 93
FAITH RINGGOLD (1930-) . 95
JEANNE-CLAUDE DENAT DE GUILLEBON (1935-2009) . . . 97
WENDY CARLOS (1939-) . 99
PAULA SCHER (1948-) . 101
HUNG LIU (1948-) . 103
ZAHA HADID (1950-2016) . 105
CHAKAIA BOOKER (1953-) . 107
KAZUYO SEJIMA (1956-) . 109
SHIRIN NESHAT (1957-) . 111
SOKARI DOUGLAS CAMP (1958-) 113
MAYA LIN (1959-) . 115
MORE WOMEN IN ART . 116
CONCLUSION . 119
SOURCES . 120
ACKNOWLEDGMENTS . 123
ABOUT THE AUTHOR . 124
INDEX . 126

INTRODUCTION

Art is more than just pretty—it's powerful! Everything around us, whether you realize it or not, has been touched by an artist. The building you live in, that billboard on the street, the pattern on your shirt—all started as concepts in an artist's mind. Many think that our ability to express ourselves creatively is what makes humans special. Both men and women have been creating art since the cave paintings of prehistoric times. Yet throughout history, women have been excluded from the story of humanity's creative expression. The women in this book had to fight sexism, classism, and racism to have their art be seen, taken seriously, and appreciated. Through their struggle to be seen, their art has made history.

Art informs our culture and either confirms or challenges our expectations of what we consider normal. Throughout history, powerful institutions all over the world have employed artists to make sure their story was told properly. Whether it was royalty spending a fortune during the Renaissance to make sure paintings depicted them perfectly, or major corporations today spending millions of dollars on advertisements to sell their products, art is a tool wielded to get a clear message across to the masses.

What happens when people take the power of art back? Many women in this book have used their talent to tell truths, to talk about injustice, and to bring visibility to the unseen, because that is when new ideas can spread and the world can begin to change for the better.

Art can be used to empower and celebrate heroes. During the height of segregation in America, many artists, including Elizabeth Catlett, were denied entry into universities due to racist policies. But Elizabeth was determined to make art that celebrated black people, and she portrayed them with beauty and strength. Today, her art depicting black leaders such as Martin Luther King Jr. and Harriet Tubman has been shown in museums around the world.

Art exposes truths and tells our shared history. When the Allied invasion of Europe came in 1944, artist Lee Miller was the only female photographer on the front line. She was one of the first photographers to document the horrors of the Holocaust. When many denied that the concentration camps were real, Lee's photographs forced the world to confront the truth.

Art creates icons and rallying cries. Although Frida Kahlo was not fully appreciated during her lifetime, the legacy of her work is a force of its own. She was rediscovered in the 1970s, decades after her death, and her work has since been shown in major museums all over the world. Through dozens of self-portraits, people saw Frida and her joy, pain, hopes, and fears. They also saw a woman who unapologetically did not conform to Western beauty standards and who proudly celebrated her Mexican heritage. Her paintings have influenced modern fashion, music, and film. Frida has become a rallying cry for feminism.

And, perhaps most important, art can heal. When Maya Lin designed the Vietnam Veterans Memorial as a twenty-one-year-old art student, she made a choice to create a new kind of monument. Rather than a traditional flag-emblazoned memorial, Maya designed a simple sloping wall, etched with the names of the fallen. The memorial opened at a time when the country was torn by defeat and divisive politics, but thousands came to mourn, and the wall allowed each visitor to grieve on his or her own terms. Art can be used to create a space that can connect us in our shared humanity.

With each brushstroke, chisel of stone, and line drawn, these women persevered. Today, we celebrate their art and their stories so we can understand how their work has influenced our lives. Art is more than just something beautiful—it shapes and reflects our world.

TIMELINE

Throughout history, women have expressed themselves by creating art. Despite not having equal access to education, training, or patronage, women artists have influenced the world. Let's celebrate the important milestones and accomplishments of women throughout art history!

25,000 B.C.E.

The oldest surviving cave paintings and sculptures are from this time. Three-fourths of cave paintings are signed with handprints that archeologists believe were made by women.

300s B.C.E.

Women worked alongside men on Grecian pottery. Women such as Helena of Egypt were written about as great painters and mosaic artists.

1399

Christine de Pizan wrote her first feminist text, *Letter to the God of Love*. Her illuminated manuscripts and poems are considered some of the earliest feminist writings in the Western world.

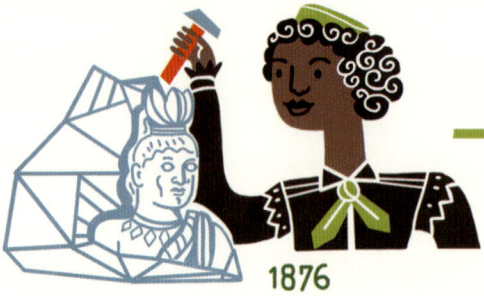

1876

Mary Edmonia Lewis was the first internationally acclaimed African American sculptor, and she had a sculpture shown at the US Centennial International Exhibition.

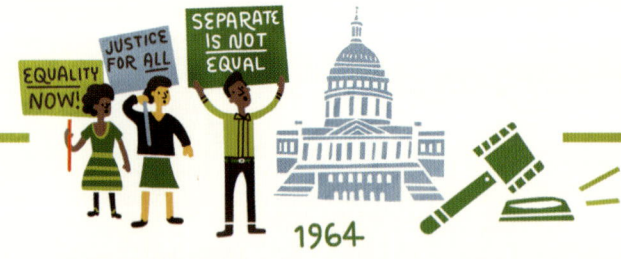

1964

Passage of the Civil Rights Act made many forms of discrimination illegal in the United States, ending racial segregation in schools and workplaces. This gave more opportunities to African Americans.

1987

The National Museum of Women in the Arts opened in Washington, DC.

A.D. 1000s

Nuns were the only women in medieval Europe with regular access to education. Both monks and nuns created illuminated manuscripts and religious objects.

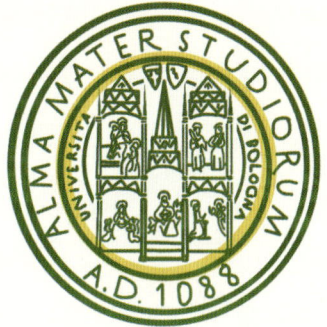

1088

The University of Bologna was founded. It was one of the earliest schools that allowed women to participate in higher education and lecture— as early as the 12th century. It officially opened to female scholars in the 18th century.

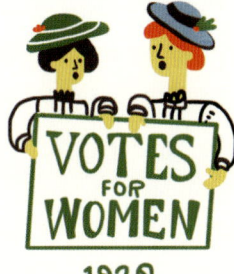

1920

Women in the United States gained the right to vote with the passage of the Nineteenth Amendment.

1942

Thelma Johnson Streat became the first African American woman to have her work purchased by the Museum of Modern Art. *Rabbit Man* (1941).

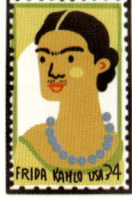

2001

Painter Frida Kahlo became the first Latina woman featured on a US postage stamp.

NOW

The next great artist can be you!

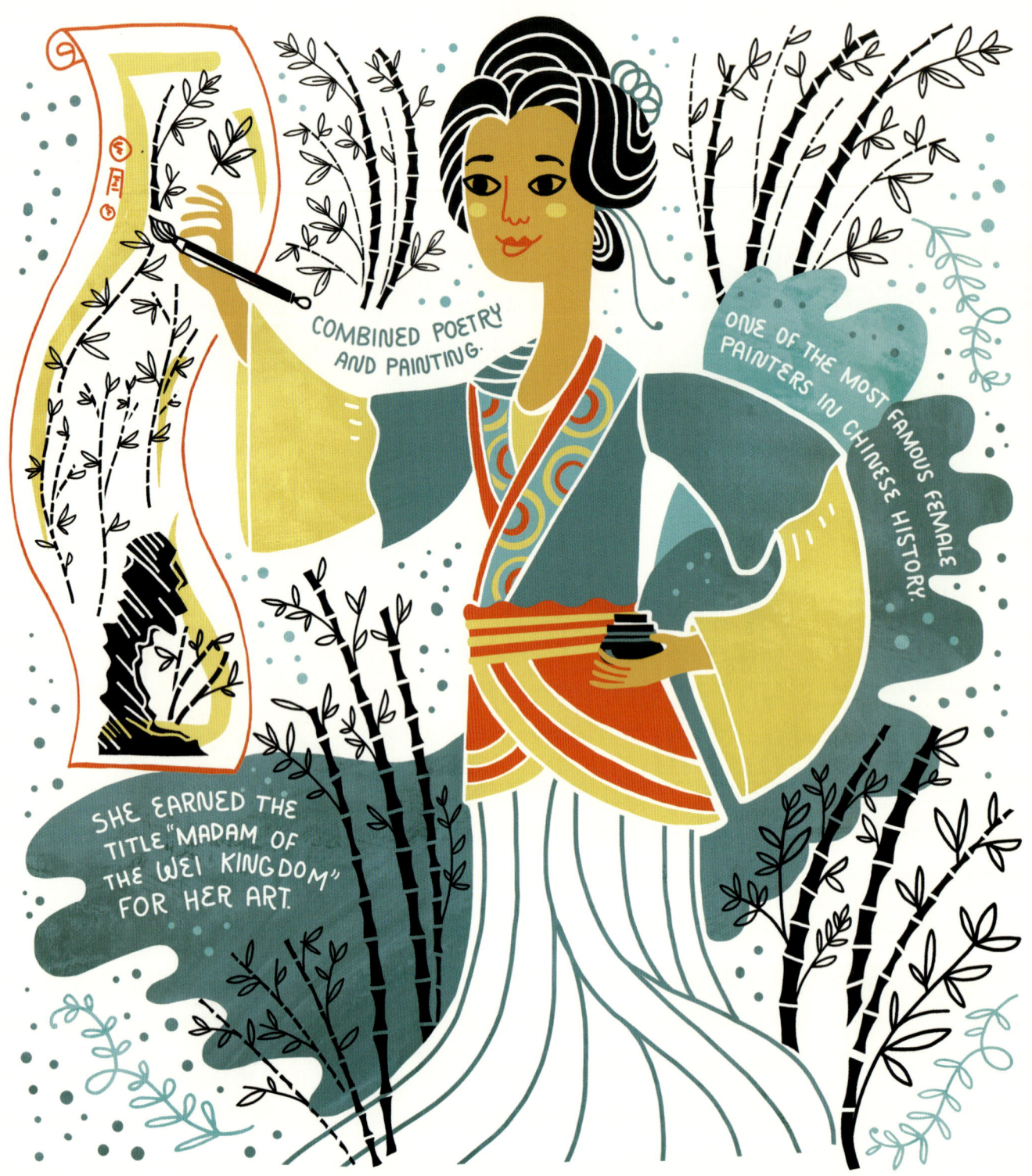

GUAN DAOSHENG
POET AND PAINTER · (1262–1319)

Born in 1262 in Huzhou, China, Guan Daosheng was one of the most famous women artists in Chinese history. At age twenty-four, she married Zhao Mengfu, a painter who worked for the emperor. She traveled with her husband while he did official imperial business all over the country. On these travels, she was able to see rural parts of China that were usually unseen by upper-class women, and she was exposed to some of the greatest artists of her time. Inspired, she began to paint in 1296. Her artwork became renowned throughout the Yuan dynasty. Emperor Renzong commissioned Guan Daosheng to copy the *Thousand Character Classic*. The Emperor showed off her work along with calligraphy examples from her husband and son.

Bamboo ink painting was a favorite subject for Guan Daosheng. At the time, bamboo was mostly painted in a "masculine" style and was used to symbolize a Chinese gentleman. Despite bamboo being such a masculine symbol in her culture, she reappropriated it to tell stories from her own life and often used calligraphy to write her own poetry directly onto her paintings. She created ink paintings that were not just iconic close-ups of bamboo, but instead she incorporated the plant into larger landscape settings, creating depth and atmosphere. Her art quickly gained a reputation among women in the Yuan court, and they frequently commissioned her work. During an era in history when most art was from the male perspective, Guan Daosheng was one of the few female artists creating art for other women.

Over her lifetime, Guan Daosheng combined her poetry and paintings to express herself. At the age of fifty-eight, she became ill, and she died in 1319. Her husband was heartbroken by her death and painted mainly bamboo to honor her memory. Today, she is remembered as a pioneer in the Chinese arts.

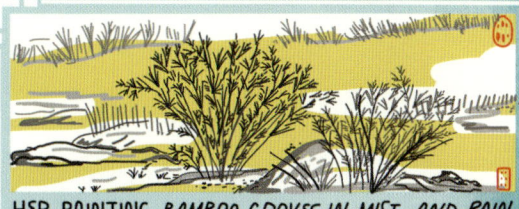
HER PAINTING *BAMBOO GROVES IN MIST AND RAIN* (1308) APPEARS IN ART HISTORY TEXTBOOKS TODAY.

HER FAME AND SKILL WERE KNOWN ACROSS THE WORLD. THERE ARE MENTIONS OF HER ART IN 14TH-CENTURY EUROPEAN MANUSCRIPTS.

LADY LI OF SHU, ANOTHER ARTIST OF THE TIME, PAINTED BAMBOO IN A "FEMININE STYLE" BY TRACING ITS SHADOWS IN THE MOONLIGHT.

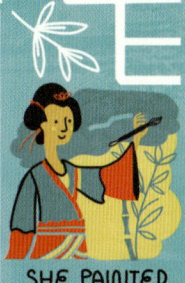
SHE PAINTED BUDDHIST MURALS FOR YUAN TEMPLES.

SHE USED BAMBOO AS A SYMBOL IN HER AUTOBIOGRAPHICAL POETRY TO TALK ABOUT HER CHILDREN, HER HUSBAND, AND HER FEELINGS ABOUT GROWING OLD.

HER SON WAS ALSO A SKILLED CALLIGRAPHER.

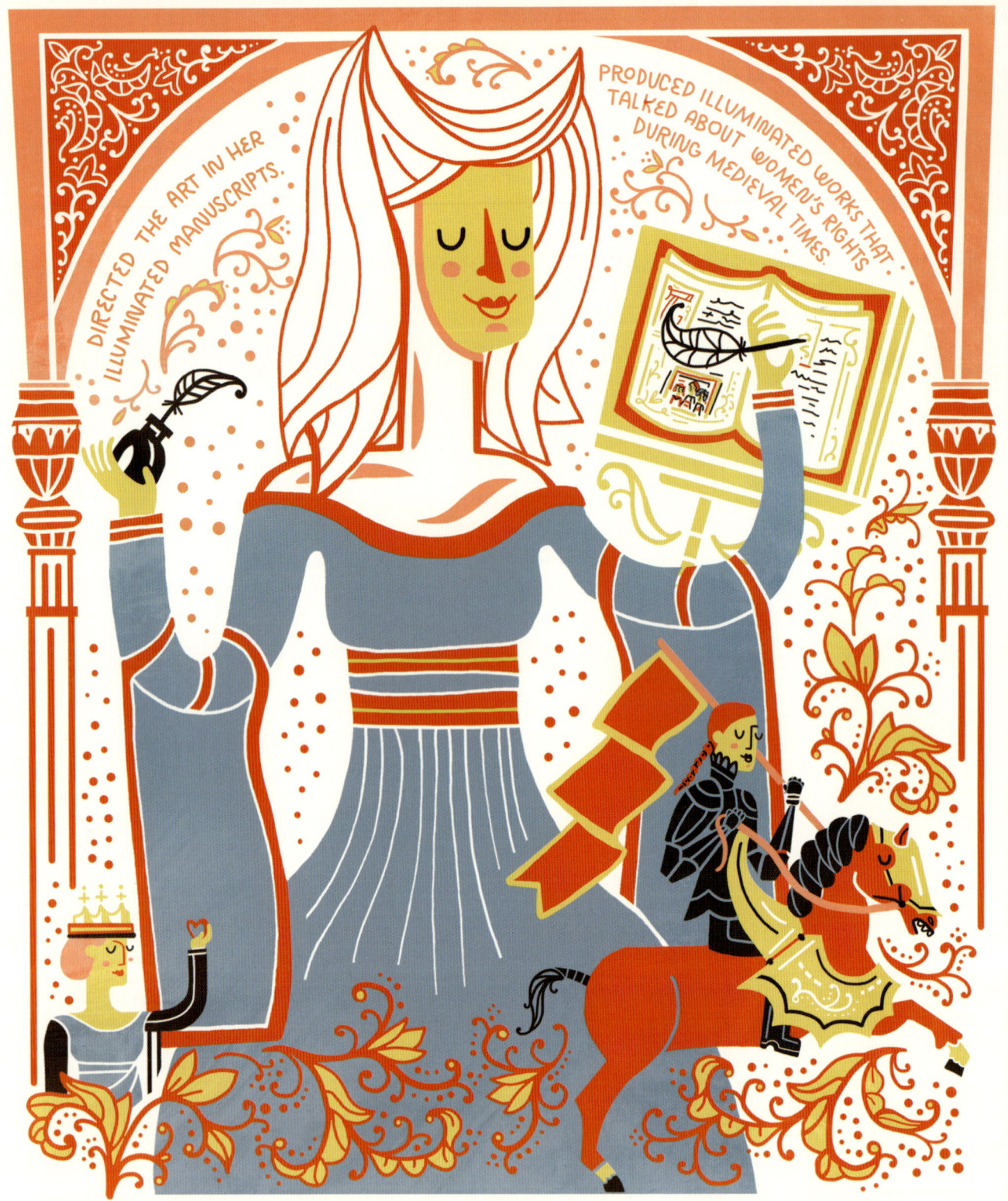

"IF IT WERE CUSTOMARY TO SEND LITTLE GIRLS TO SCHOOL AND TEACH THEM THE SAME SUBJECTS AS ARE TAUGHT TO BOYS, THEY WOULD LEARN JUST AS FULLY AND WOULD UNDERSTAND THE SUBTLETIES OF ALL ARTS AND SCIENCES." —CHRISTINE DE PIZAN, *THE BOOK OF THE CITY OF LADIES*

CHRISTINE DE PIZAN
AUTHOR AND ART DIRECTOR OF ILLUMINATED MANUSCRIPTS (1364-1430)

Christine de Pizan was born in Italy in 1364. At a young age, Christine moved to Paris when her father was appointed as an astrologer for the French royal court. In medieval France, most women were not educated, nor had professions of their own. Instead, many girls were arranged to be married when they were as young as twelve or fifteen years. So it was exceptional that Christine was taught to read and write by her father. She spent her youth exploring the court's libraries and fell in love with books.

At fifteen, Christine married a nobleman and scholar, Etienne du Castel. She continued her studies, and her husband encouraged her writing, which was unusual for the time. After ten years of marriage, Etienne died, widowing Christine at twenty-five. She had three children to support and two choices: remarry or use her talent to provide for her family. In the Middle Ages, it was acceptable for a widow to run a business, so she began her career by sending her poetry and prose to members of the court. She also started transcribing and illustrating other people's work. At that time, the illustrations that accompanied writing were incredibly important because very few people could read. These heavily illustrated texts were called illuminated manuscripts. By 1393, she became popular with the royal court for her love poems about her late husband. Many noblemen and even the Queen of Bavaria were patrons of her work, and Christine was able to fully provide for her family.

Christine began writing about politics, morality, and the strength of women. One of her most important and famous books, *The Book of the City of Ladies*, was published in 1405. In it, she writes about the heroism of women throughout history and the oppression they faced in medieval Europe. In this book, Christine describes a utopian city built just for women in which they live without fear of misogyny.

Christine was one of the only authors who was involved in every step of creating an illuminated manuscript. She choose who illustrated her books and closely art directed every detail. Throughout Christine's career, she produced forty-one pieces of poetry and prose and became famous and well respected. In 1418, she retired to a convent near Paris. There, she wrote her last poem, *The Song in Honor of Joan of Arc*, in 1429.

WORKED WITH A FEMALE ILLUSTRATOR NAMED ANASTASIA.

ILLUMINATED MANUSCRIPTS HAD GOLD LEAF ON THEIR PAGES AND WERE LUXURY ITEMS FOR THE WEALTHY.

IN 1404, SHE WROTE A BIOGRAPHY CALLED THE BOOK OF THE DEEDS AND GOOD MORALS OF THE WISE KING CHARLES V.

MANY MALE AUTHORS OF THE TIME MADE SEXIST REMARKS ABOUT WOMEN BEING "SEDUCERS." CHRISTINE SPOKE OUT AGAINST THIS BY WRITING *THE TALE OF THE ROSE* (1402).

IN AN ILLUMINATION FROM *THE BOOK OF THE CITY OF LADIES*, CHRISTINE IS SHOWN HELPING BUILD A NEW CITY WITH 3 WOMEN WHO EACH SYMBOLIZE RECTITUDE, REASON, AND JUSTICE.

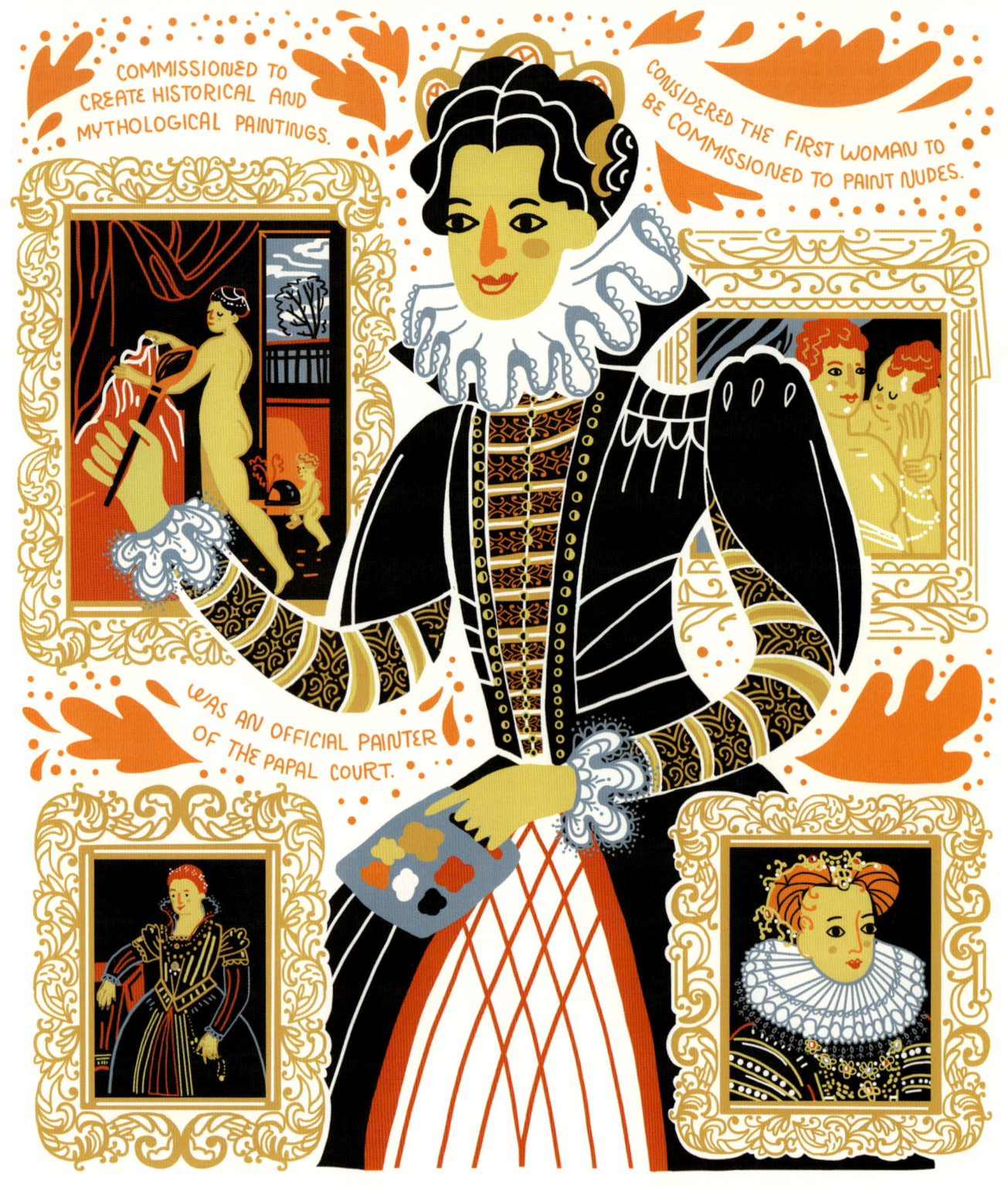

LAVINIA FONTANA
PAINTER · (1552-1614)

Lavinia Fontana was born in Bologna, Italy, in 1552 during the middle of the Renaissance. Although it was a revolutionary time for European culture, many people still thought it was dangerous for women to be educated. Women were not allowed to formally apprentice as artists or study from nude models. Despite all of this, Lavinia Fontana persevered, and during her lifetime would become one of the most important and highest-paid painters in Italy.

In Lavinia's time, only women with artists in their families could get a formal art education. Lavinia's father was a master painter and chose to train Lavinia in his craft. Even as a young woman, Lavinia's talent was so apparent that her father decided that she would take over his studio. As Lavinia trained, it was still seen as immodest for a woman to study nude figure drawings from real models. Instead, she learned how to draw proper human anatomy from nude sculptures.

She began her career by painting portraits of upper-class women in Bologna. These women, wanting to display their wealth, would wear their most expensive outfits for their portraits. Lavinia's paintings were highly detailed, and she impressed her patrons by capturing every bead, every pearl, and every intricate pattern and lace on their frocks. As the head of her own studio, her fame spread throughout Italy. In 1603, Pope Clement VIII invited her to Rome, and she became an official painter of the papal court. She received commissions to paint important historical and mythological subjects. She is also known as the first woman in the Western world to create publicly commissioned paintings of nudes! She was equal in every way to her male peers in subject matter and payment, proving that women were capable of painting serious and prestigious commissions.

Lavinia did a tremendous amount of work over the course of her career and was one of the most prolific female artists in her lifetime. It is thought that she painted more than one hundred portraits, and there may be even more works of hers that are unattributed. She died in 1614, leaving behind a legacy that paved the way for other female artists to create work on a grander scale than ever before!

DURING THE RENAISSANCE, PEOPLE THOUGHT ARTISTIC TALENT WAS A GIFT FROM GOD, AND MOST LARGE-SCALE ART WAS MADE FOR AND FUNDED BY THE CATHOLIC CHURCH.

SHE EARNED A DEGREE FROM UNIVERSITY OF BOLOGNA IN 1580.

UNLIKE OTHER SCHOOLS, WOMEN STUDIED THERE AND WERE OFFICIALLY ADMITTED IN THE 1700s.

HER LARGEST PAINTING WAS THE 20-FOOT-HIGH MURAL *THE STONING OF ST. STEPHEN*.

HER HUSBAND, COUNT PAOLO ZAPPI, WAS HER ASSISTANT IN THE STUDIO AND HELPED MANAGE THEIR HOME, A ROLE THAT WAS UNUSUAL FOR THE TIME.

IN 1611, A BRONZE MEDAL WAS SCULPTED IN HER HONOR.

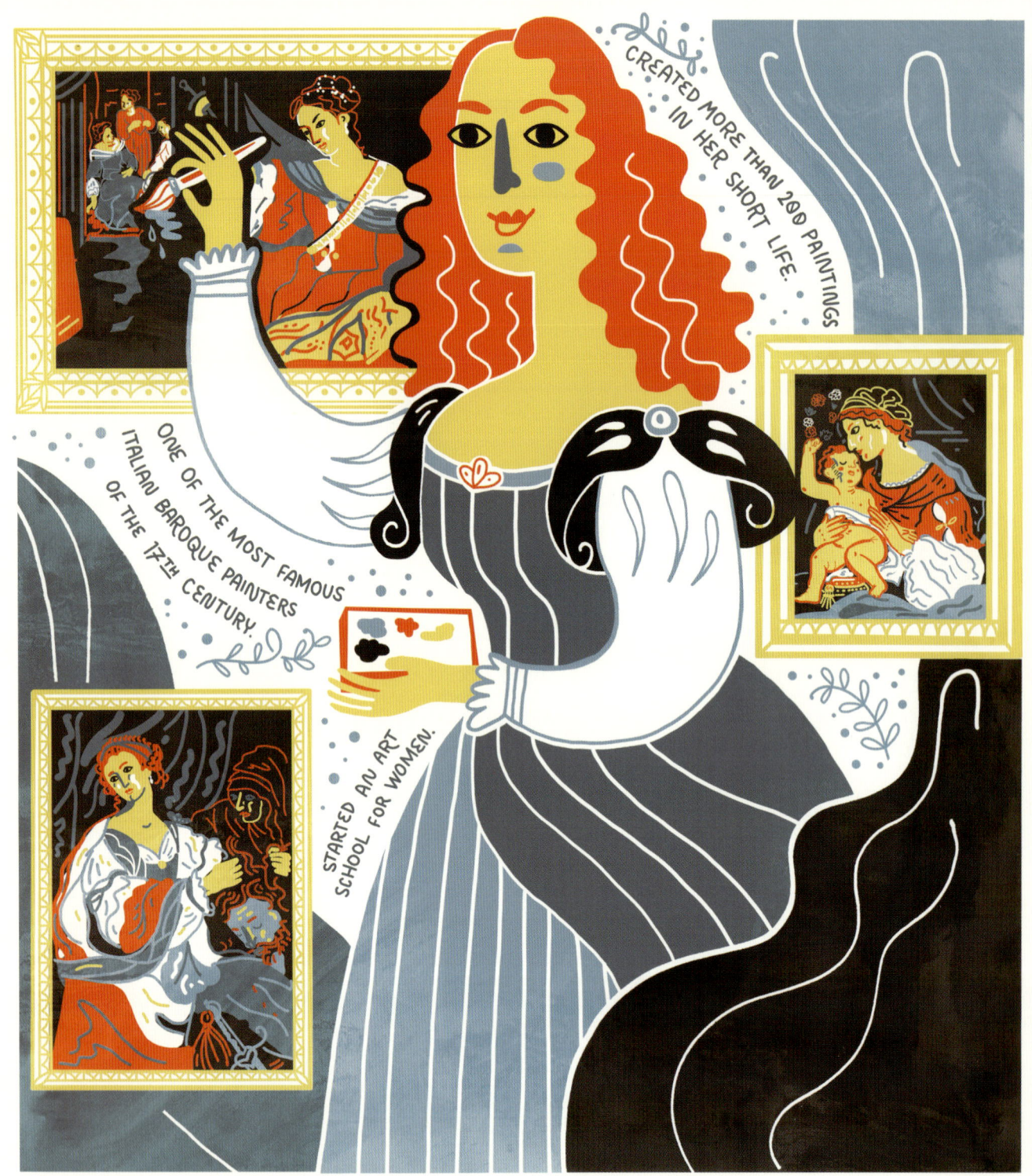

ELISABETTA SIRANI
PAINTER AND PRINTMAKER (1638-1665)

SHE HAS BEEN COMPARED TO RENAISSANCE ARTIST RAPHAEL, FOR HER TALENT, BEAUTY, AND GOOD NATURE.

AS A CHILD, SHE LEARNED ABOUT MYTHOLOGY, AND HOW TO SING, PLAY THE HARP, AND WRITE.

DURING HER TEN-YEAR CAREER, SHE KEPT A DETAILED LIST DOCUMENTING ALL HER WORK.

Elisabetta Sirani's life was brief, but her accomplishments made her legendary. In just ten years, she made more than two hundred paintings and hundreds of drawings—all in the highly detailed and dramatic style of the baroque period. Although she died at the young age of twenty-seven, she is considered one of the greatest Italian painters of the 17th century.

Elisabetta was born in 1638 in Bologna, Italy. When she was just a little girl, it was clear that she had great artistic talent. Her painter father, Giovanni Andrea Sirani, began to train her, and she quickly surpassed him in skill and speed. By seventeen, she was creating masterful oil paintings that sold for high prices. Throughout her career, her paintings caught the attention of cardinals, royalty, and even a member of the famous and wealthy Medici family (the most powerful art patrons of Europe!). Elisabetta's father pushed her to create even more profitable work at an even faster pace and kept all of the money for himself. In 1654, he became debilitated from gout (which often is caused by rich food and lots of sitting), and, at nineteen, Elisabetta took over his studio. The sale of her artwork provided for her entire family; this pressure to create and earn money made her one of the most prolific painters in all of Italy.

Like other baroque artists of the time, Elisabetta's work was filled with richly detailed, larger-than-life scenes from mythology and religion. She produced so many paintings—from portraits to large scenes—in such a short period of time that some critics did not believe she could have made them all. People started spreading stories that men were painting her work for her. In 1664, Elisabetta put the rumors to rest when she invited her slanderers to watch her paint. They were surprised and impressed once they saw exactly how quickly she turned a blank canvas into a fully realized painting.

Elisabetta founded one of the first schools in Europe specifically for female artists. It was one of the only places, outside of religious convents, where women could learn from female master painters. At the age of twenty-seven, Elisabetta died tragically of a stomach ulcer. She was so beloved in Europe that her funeral procession was a festival of musicians, poets, and artists honoring her memory. Many of her students went on to become great painters as well. Her work can still be seen in major international museums today.

FOR HER FUNERAL, AN ARTIST DESIGNED A LIFE-SIZE STATUE OF ELISABETTA AT HER EASEL.

HER PAINTING VIRGIN AND CHILD WAS SELECTED FOR A US POSTAL STAMP IN 1994.

CHIAROSCURO (ITALIAN FOR "LIGHT-DARK") IS AN ART TERM FOR A BAROQUE PAINTING STYLE WHERE SUBJECTS ARE SHARPLY LIT WITH HIGH CONTRASTS AGAINST A DARK BACKGROUND.

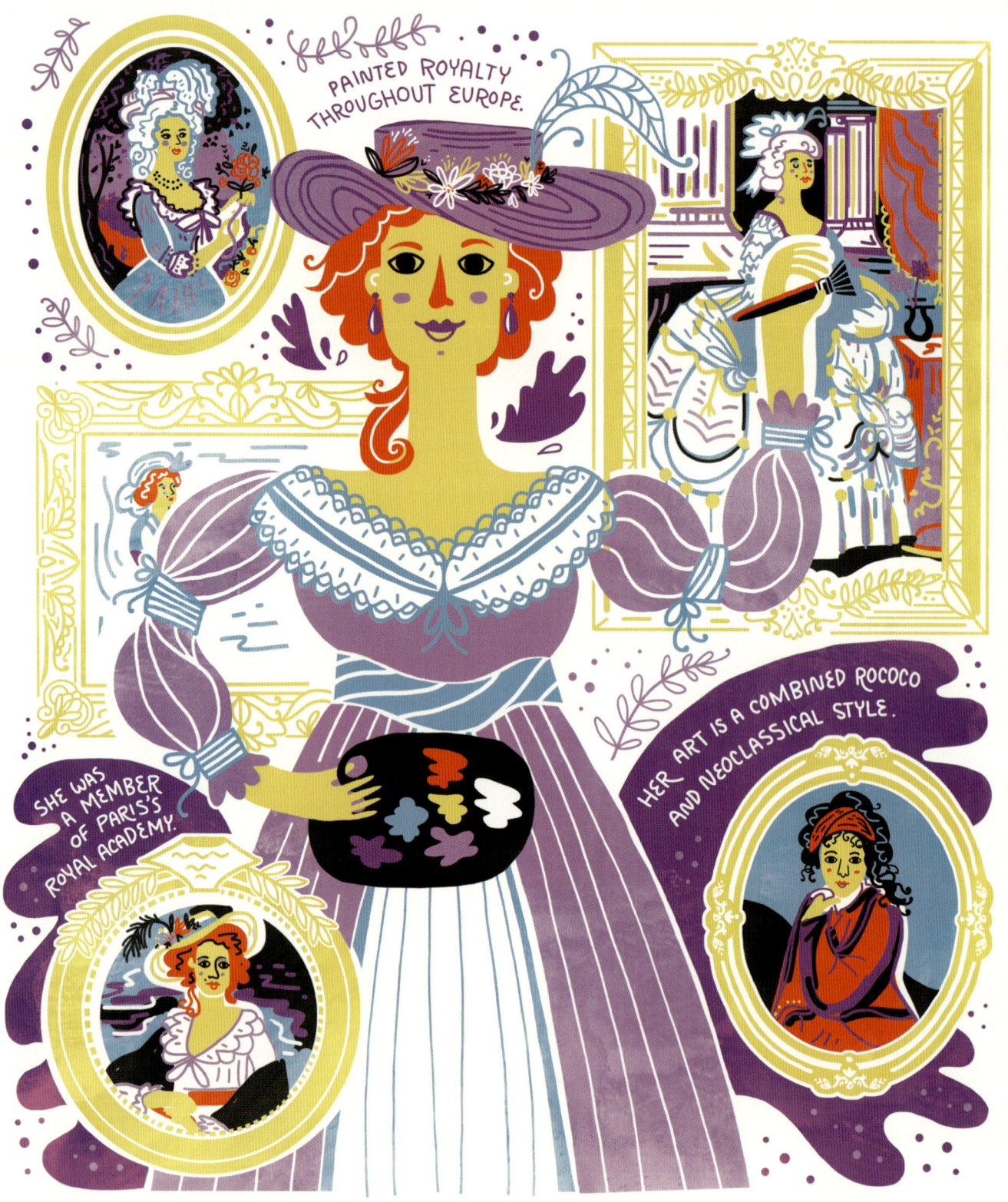

ÉLISABETH LOUISE VIGÉE LE BRUN
PAINTER · (1755-1842)

WAS GIVEN HONORARY MEMBERSHIPS AT FIVE EUROPEAN ACADEMIES.

MARIE ANTOINETTE IN A CHEMISE DRESS (1783).

PAINTED MARIE ANTOINETTE WEARING COMMON CLOTHES, AND IT SCANDALIZED THE VERSAILLES COURT.

SHE PUBLISHED HER OWN MEMOIR, SOUVENIERS, IN 1835.

Élisabeth Louise Vigée Le Brun was as well known for her charm as she was for her paintings, and both helped her fit right in at the French royal Palace of Versailles. Élisabeth's rococo-style portraits showed the fantasy-level lavishness of the opulent 18th-century French court.

Born in 1755 in Paris, as a child, Élisabeth would paint on any surface available, including the walls. Her father, a talented pastel artist, taught her how to paint. Unfortunately, he died when Élisabeth was only twelve years old. Luckily, he had taught her the skills needed to become a professional. She began painting commissions at age fifteen, and by nineteen, she was made a member of the Académie de Saint-Luc. In 1774, Élisabeth married art dealer Jean-Baptiste-Pierre Le Brun. She showed in salons and hotels, and even turned her home into an exhibition space. Soon Élisabeth was painting the nobility of Paris.

At the age of twenty-four, Élisabeth painted Queen Marie Antoinette for the first time. She became the queen's favorite painter and good friend. Élisabeth was soon one of the most sought-after painters among the members of the court, and her work created fashion trends all over Europe. Her oil paintings were like today's fashion magazines, featuring the stylish, rich, and famous. In 1783, she became one of the few female members of the prestigious Royal Academy of Painting and Sculpture.

While the Palace of Versailles was covered in gold furniture and wall-to-wall oil paintings, most of France's population was starving. The French Revolution was brewing and would soon put a violent end to anyone associated with the aristocracy. Fearing for her life, Élisabeth took her child and escaped to Italy in 1789. In September 1792, the monarchy was overthrown, and Queen Marie Antoinette, King Louis XVI, and the many members of the court were later executed. Élisabeth would not return to France for twelve years. With her charisma and talent, she was one of the only members of the court who survived and thrived after the revolution. She painted royalty and nobility throughout Europe and returned to France in 1802, once her safety was assured. Élisabeth died at the age of eighty-six in Paris, as one of the wealthiest and most respected painters of her time. Her work captured a unique moment in history and, today, you can still see her portraits in major museums all over the world.

STARTED AN ART GALLERY (CALLED A SALON) IN FRANCE AFTER SHE RETURNED FROM EXILE.

IN 1787, SHE PAINTED HERSELF WITH A HAPPY SMILE (WITH TEETH!) THAT CAUSED CONTROVERSY BECAUSE A TOOTHY GRIN WAS AGAINST THE ETIQUETTE RULES OF THE DAY.

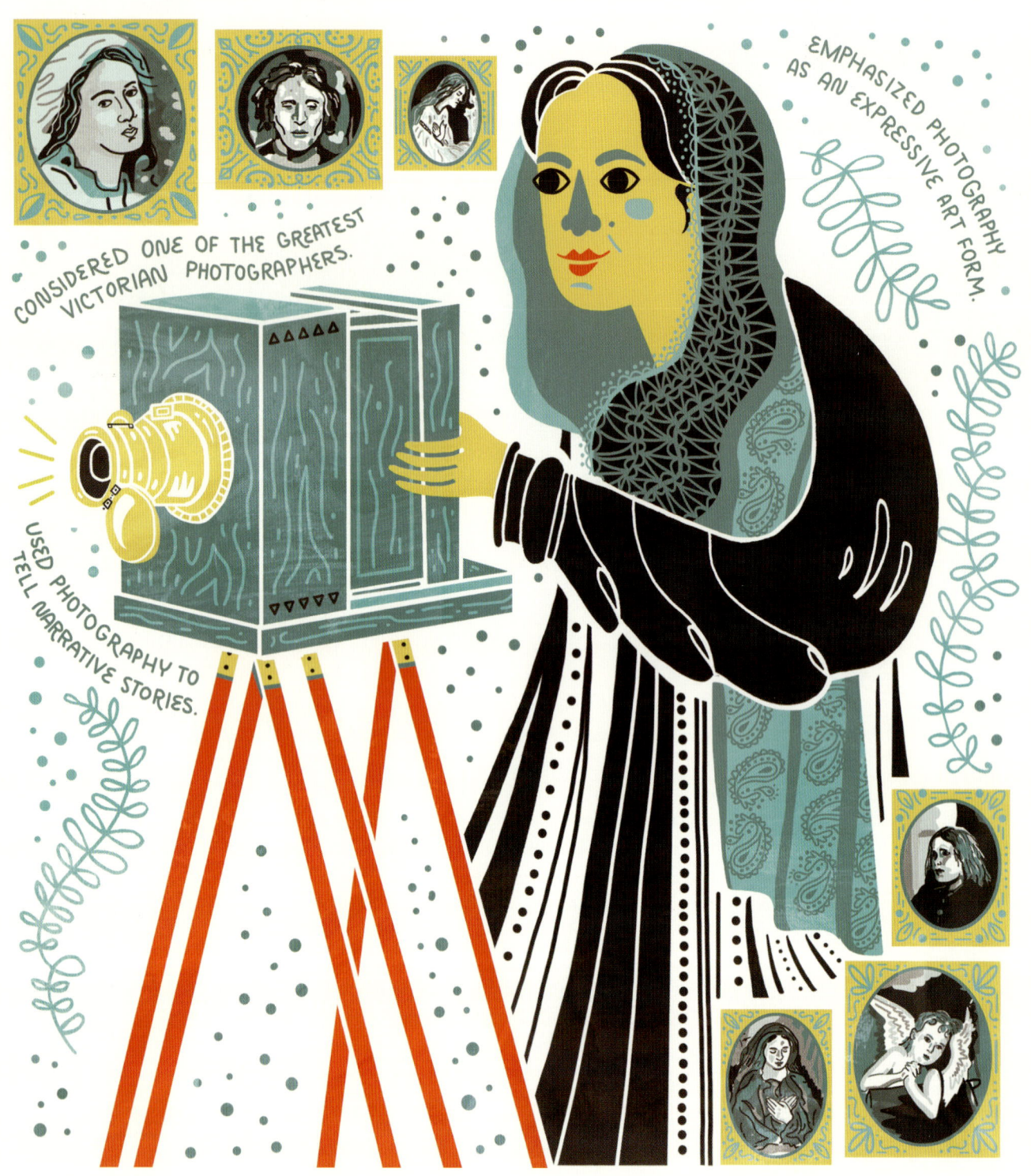

JULIA MARGARET CAMERON
PHOTOGRAPHER (1815–1879)

IN 1800, THOMAS WEDGWOOD WAS THE FIRST PERSON TO EXPERIMENT WITH CAPTURING CAMERA IMAGES ON LIGHT-SENSITIVE MATERIAL.

IN 1822, JOSEPH NICÉPHORE NIÉPCE INVENTED HELIOGRAPHY, THE FIRST KNOWN PERMANENT PHOTOGRAPHIC PROCESS.

TURNED A HENHOUSE INTO HER PHOTOGRAPHY STUDIO.

IN 1864, SHE PHOTOGRAPHED A FAMILY FRIEND AND ACCIDENTALLY USED SOFT FOCUS TO CREATE WHAT SHE CALLED HER "FIRST SUCCESS."

JULIA ONCE MADE HER FAMILY DRESS UP AS ANGELS AND POSE WITH STUFFED SWANS.

Julia Margaret Cameron was born in 1815 in Calcutta during the British colonization of India. In 1848, she moved to England with her husband and six children. Julia's life would change at the age of forty-eight when she received a special gift—one of her children gave her a wooden camera. As soon as Julia looked through the lens, she was inspired. In 1863, Julia started her prestigious career in portrait photography and would change the art form forever.

Photography was a new technology, and to create a sharp image, the person in the photo had to stay extremely still for a long time. This produced very stiff and formal portraits. The philosophy of photography was more of a science than an art, and photographers strived to get the most detailed image that "preserved life."

Julia did things differently. She would allow her subjects to move, embracing happy accidents and expressive blurs. She wanted to capture people's emotions, which made her images feel alive and dreamlike. Her unorthodox techniques made revealing a person's inner character a priority over creating a crisp image. Julia broke all of the rules, although historians have debated whether or not she did so consciously. She wanted her photos to tell a story, and in doing so she pushed the boundaries of photography as an expressive art form.

As an upper-class woman, Julia was well read in literature, history, and mythology. She used her photographs to tell her favorite stories, dressing her models in Shakespearean robes, medieval crowns, and biblical costumes and styling them in dramatic poses.

Many photographers criticized her work as unprofessional, but she was praised by painters as one of their own. With enthusiasm and boundless creativity, she photographed famous artists and scientists, including Charles Darwin, Alfred Lord Tennyson, and John Herschel. She photographed her family, her staff, and was even known to chase strangers down the street until they posed for her camera.

Over the course of eleven years, Julia created a massive body of work of more than 1,200 photos. Today, her work hangs in major museums all over the world, and she is remembered as a woman who helped establish a new art form.

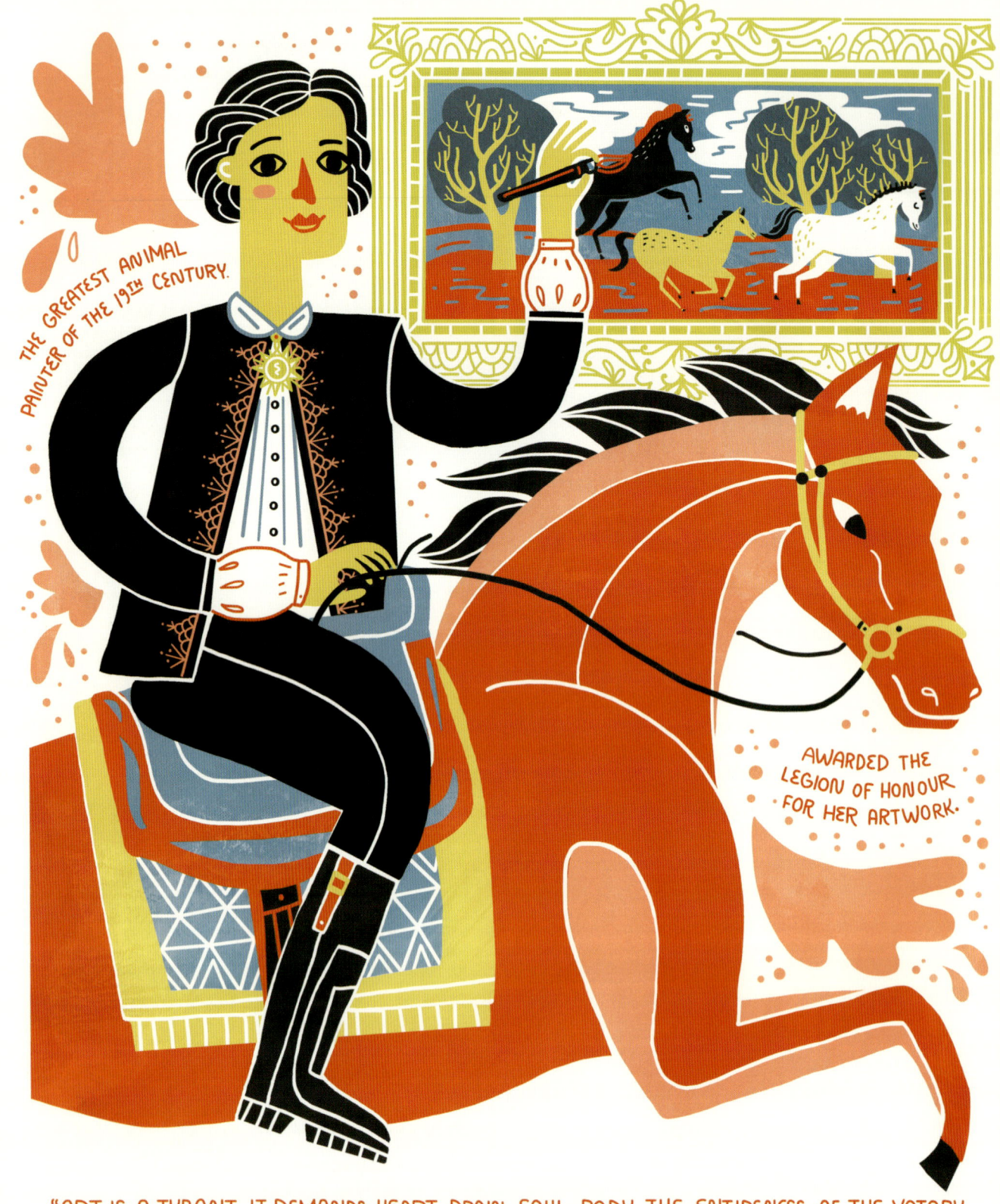

ROSA BONHEUR
PAINTER · (1822-1899)

In the 19th century, there were strict "rules" that policed gender expression, and women were expected to act "ladylike" and be "delicate." But Rosa Bonheur broke every rule. She was the greatest animal painter of her time and would not have been caught dead wearing a corset or riding sidesaddle. Instead, Rosa got her hands dirty sketching animals up close and was known for her "masculine" outfits and painting style. It didn't matter to her what others thought. Rosa never compromised being herself.

She was born into a family of French artists in 1822, and her parents supported her education and aspirations to paint. Wild animals inspired her as she played in the countryside. When her family moved to Paris in 1828, she would study and do sketches in the city's famous museums.

Rosa's paintings were about accurately depicting animals in their natural environment. To make sure her paintings were anatomically correct, she often did sketch studies on farms, where she could get close to the animals. Her careful observations paid off, and she achieved the first of her many showings in the Paris Salon in 1841.

In 1852, Rosa began painting her masterpiece *The Horse Fair*, which she finally completed in 1855. At 8 feet tall and more than 16 feet wide, you can feel the energy, movement, and strength of the horses on the canvas. This painting debuted in the Paris Salon in 1853 and turned Rosa into a worldwide sensation. Lithographs (a method of printmaking) reproduced *The Horse Fair* and allowed people all over Europe and America to enjoy her work. Both Emperor Napoleon III and Queen Victoria asked to view her original painting. Rosa became so famous that songs were written about her.

Throughout her lifetime, Rosa was openly a lesbian and did not hide whom she loved, fellow female artist Nathalie Micas, who was her partner for over forty years. After Nathalie's death in 1889, Rosa fell in love with her new partner, Anna Elizabeth Klumpke. When Rosa died in 1899, she left her estate and fortune to Anna.

Despite the bigotry and violence faced by gay people, Rosa's sheer talent forced the world to accept her, and by doing so, she paved the way for both female and queer artists. Rosa lived her life authentically, whether it was galloping full speed on a mustang or simply loving fully.

IN 19TH-CENTURY PARIS, PANTS ON A WOMAN WAS SCANDALOUS. EVERY SIX MONTHS, ROSA HAD TO RENEW A GOVERNMENT PERMIT THAT ALLOWED HER TO WEAR PANTS IN PUBLIC.

AMERICAN SHOWMAN "BUFFALO BILL" WAS SUCH A FAN OF ROSA'S THAT HE GIFTED HER TWO MUSTANG HORSES.

AT HER HOME, THE "CHÂTEAU DE BY," SHE KEPT FARM ANIMALS, GAZELLES, YAKS, ICELANDIC HORSES, AND LIONS!

GROWING UP, SHE ATTENDED A BOYS' SCHOOL WITH HER BROTHERS.

AS A CHILD SHE HAD TROUBLE READING, SO SHE LEARNED THE ALPHABET BY DRAWING ANIMALS FOR EACH LETTER.

HARRIET POWERS
QUILTER · (1837-1910)

SOLD HER FIRST QUILT AT AGE 53.

HER QUILTS SHOW INFLUENCES FROM WEST AFRICAN DESIGNS.

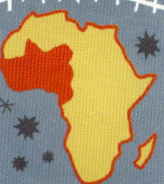

HARRIET'S BIBLE QUILT IS BOTH HAND-STITCHED AND MACHINE-STITCHED.

In 1837, Harriet Powers was born into slavery near Athens, Georgia. Along with the many brutal practices of slavery, teaching slaves to read was against the law. But Harriet, like many of the women before her, would use her artistry to create storytelling quilts that helped share an oral history. Her quilts depict important legends, Bible stories, and astronomical events. After the Civil War, in 1865, slavery was made illegal by the Thirteenth Amendment to the US Constitution. At the age of twenty-eight, Harriet Powers was finally free, and she and her family managed to own some land and a home.

In 1886, Harriet displayed her now-famous Bible Quilt at the Cotton Fair in Athens, Georgia. The quilt captured the eye of white art teacher Jennie Smith, who offered to purchase it on the spot for $10 (which would be more than $240 today). Harriet could not bear to part with her precious quilt and declined to sell it.

In 1865 and 1866, the Black Codes were enacted in the South to strip away the rights of newly freed slaves and to ensure that plantations continued to have nearly free labor. The South was struggling economically after the war. Times became hard for Harriet and her family and they had to sell off parts of their land. Four years after the Cotton Fair in Georgia, and after discussing it with her family, Harriet decided to sell her precious Bible Quilt. She sold it to Jennie Smith for $5 but made sure that Jennie wrote down a description of the story each square told so that her quilt's meaning would remain. This sale of her work helped Harriet's family keep their home.

Little is known about Harriet's quilting career, but there is record of her being hired to create several more quilts. She died in 1910 at the age of seventy-two. Today, two of her quilts still survive in the collections of major museums. Harriet Powers did not obtain wealth or fame with her artwork during her lifetime, but the beauty of her quilts has allowed them to endure for over 130 years. Her work shares an aspect of the private lives, hopes, dreams, and strength of the people who survived slavery and gives visibility to African American Southern life during the Reconstruction era.

HER BIBLE QUILT DEPICTED SCENES SUCH AS JONAH AND THE WHALE, CAIN AND ABEL, JACOB'S LADDER, AND, THE LAST SUPPER.

MANY THINK THAT HER PICTORIAL QUILT (1895-98) WAS ORIGINALLY COMMISSIONED BY A GROUP OF "FACULTY LADIES" AT ATLANTA UNIVERSITY.

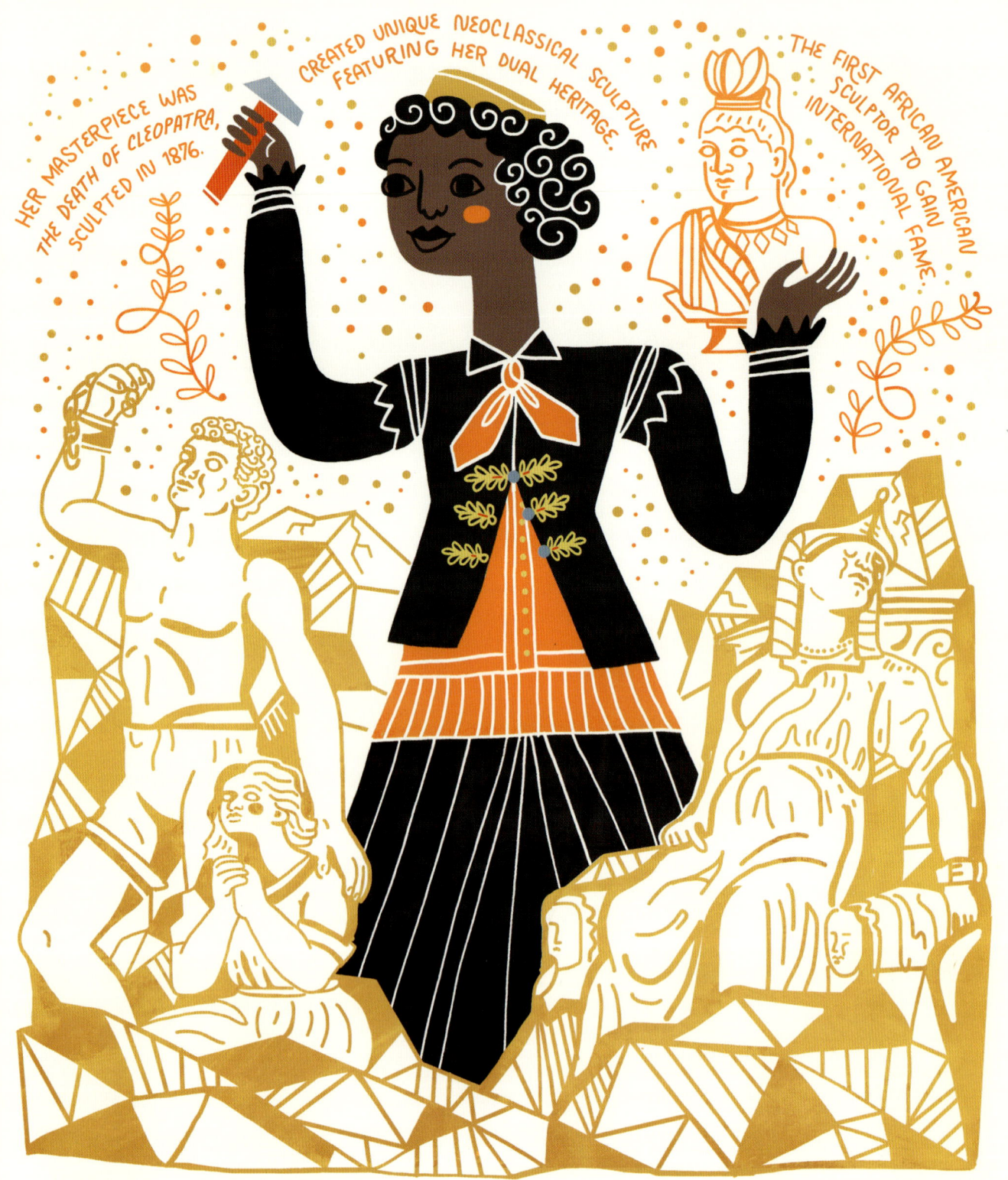

MARY EDMONIA LEWIS
SCULPTOR · (1844-1907)

SCULPTED NATIVE AMERICAN THEMES SUCH AS THE STATUE OLD ARROW MAKER (1872).

THE DEATH OF CLEOPATRA (1876) WAS SOLD TO A RACETRACK AND WAS LATER RESTORED IN THE 1990s AND DONATED TO THE SMITHSONIAN.

Mary Edmonia Lewis was born in 1844 somewhere in the American Northeast. Her father was African American, her mother was Native American. She lost both of her parents at a very young age and was raised by her mother's family. As a person of color in the mid-19th century, educational opportunities were few, but luckily Edmonia had a brother who helped pay for her education. At the time, Oberlin College was the first (and practically only) school of higher education that admitted both women and African Americans. Edmonia enrolled there at age fifteen.

The Civil War would begin two years after Edmonia entered college, and just because slavery was illegal in the North didn't mean that segregation, racism, and violence didn't exist there too. In school, Edmonia was wrongfully accused of poisoning her two roommates. She was innocent, but the damage had been done and a racist, angry mob attacked her. For her own safety, she dropped out of school in 1863.

The following year, Edmonia moved to Boston to learn how to sculpt. She began by creating clay busts of abolitionists and Union army generals. Her work was very popular, and she was able to sell reproductions. With this money, Edmonia traveled to Rome and was inspired by the marble statues of the old renaissance masters. The 18th- and 19th-century neoclassical art movement was about capturing the style and technique of ancient Greek and Roman sculpture.

In Europe, Edmonia learned to work in marble with a group of other female sculptors. Her work was unique; unlike the other neoclassical artists, she sculpted indigenous people and African Americans. In 1867, she sculpted *Forever Free*, which showed a black man and woman breaking the chains of slavery—a celebration of African American liberation at the end of the Civil War. She became successful and internationally famous. In Italy's more accommodating climate, she was celebrated for her proud political statements as a black woman. For the 1876 Centennial International Exposition in Philadelphia, Edmonia created her ultimate 3,015-pound marble masterpiece. It was called *The Death of Cleopatra* and featured a defiant black queen heroically allowing herself to be bitten by a snake.

Mary Edmonia Lewis died in 1907. Her sculptures made the whole world celebrate her heritage and continue to inspire and empower people today.

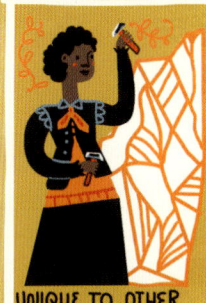

UNIQUE TO OTHER MARBLE SCULPTORS, EDMONIA ALMOST NEVER USED ASSISTANTS, AND CARVED ALL OF THE STONE HERSELF.

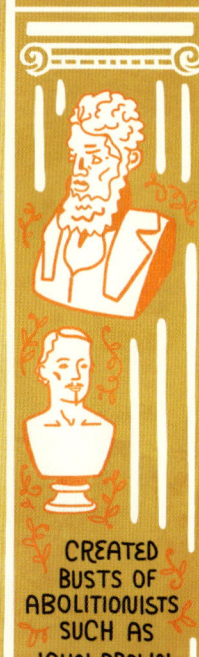

CREATED BUSTS OF ABOLITIONISTS SUCH AS JOHN BROWN AND ROBERT GOULD SHAW.

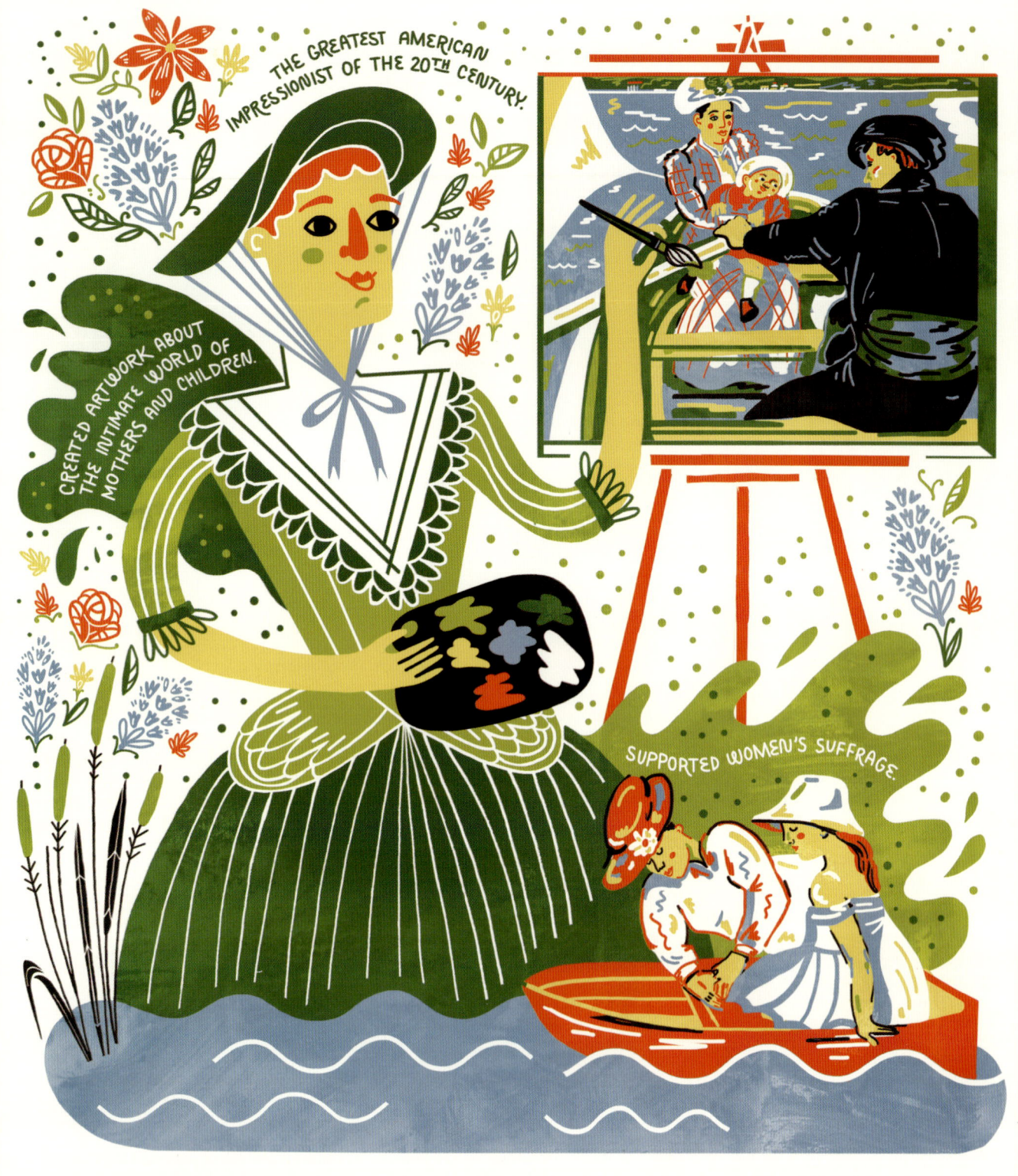

MARY CASSATT
PAINTER · (1844-1926)

AMERICANS WOULD TRAVEL TO PARIS JUST TO VISIT HER ESTATE, THE CHÂTEAU DE BEAUFRESNE.

WOOD-BLOCK ART PRINTS BY JAPANESE ARTIST KITAGAWA UTAMARO INSPIRED HER TO START PRINTMAKING.

ORGANIZED ART SHOWS AND BENEFITS TO RAISE MONEY FOR WOMEN'S SUFFRAGE.

In the late 19th century, upper-class women in Europe and the United States began to push the boundaries of society's expectations. The "new woman" married by choice, was educated and independent, and pursued her own passions. Around the same time, a new rebellious art movement called impressionism began in Paris. While the art world was traditionally very rigid and valued realism above all else, the impressionists captured fleeting moments in time with blurry brushstrokes and a focus on color, movement, and light. In between these two movements was Mary Cassatt.

Mary was born near Pittsburgh in 1844. The Cassatts visited Europe to make sure their kids grew up with culture, but the educational travel worked a little too well. Young Mary fell in love with the art world of Paris. Against her parents' wishes, she enrolled at the Pennsylvania Academy of the Fine Arts at age fifteen. In 1866, Mary moved to Paris to continue her art studies. She loved Paris, but the Franco-Prussian War forced her to return to the United States. In 1871 she returned to tour Europe, and in 1874, Mary officially made Paris her home. For a long time Mary's paintings were a sensation in the Paris Salon, but in 1877, for the first time in seven years, the Salon refused her work. The Salon said her brush work was too loose and too colorful, but her work impressed painter Edgar Degas. He invited her to join an art show and Mary became part of their French avant-garde group called the Impressionists.

In the 1890s, she broke away professionally from Degas. She'd had enough of his chauvinism and sexist comments about her paintings. Mary began creating portraits of modern women in their daily lives. While many of her male colleagues painted women as subjects of male desire, Mary instead showed women in their own domain, free from the male gaze. She captured the intimate world of mothers and their children, as seen in paintings such as *The Child's Bath* (1893). This became her best known body of work.

Mary spent her life traveling the world, painting and mentoring young artists. In 1914, she lost her eyesight and was forced to stop working. She died in 1926 and is remembered as one of the great artists that defined the late 19th century.

AS A FAMOUS AMERICAN IN PARIS, SHE INTRODUCED PARISIAN ARTISTS SUCH AS DEGAS AND MONET TO US GALLERIES.

VISITED EGYPT AND WAS OVERWHELMED BY THE BEAUTY OF THE ANCIENT WALL PAINTINGS, DECLARING HERSELF...

"CRUSHED BY THE STRENGTH OF THIS ART."

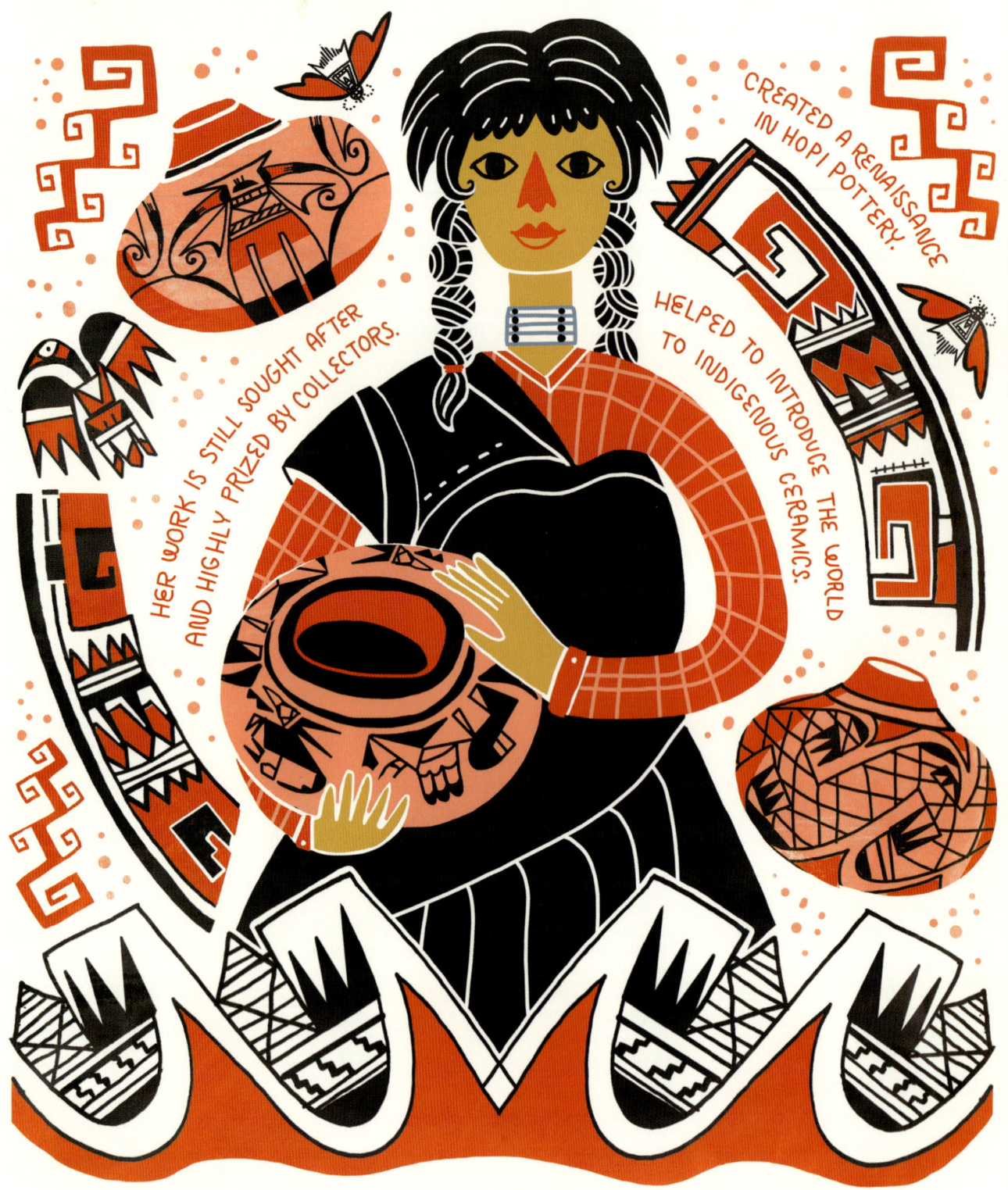

NAMPEYO
CERAMIC ARTIST · (1859-1942)

Nampeyo was the first internationally known Native American ceramic artist and single-handedly sparked a renaissance in the art form. She was born in 1859 and grew up on ancestral Hopi lands in Arizona. At the time, the traditional technique of making Hopi pottery was a lost art, and the pots being made were thin and would crack. Nampeyo found shards of old Hopi pottery that had been made 300 years before she was born—the designs were geometric and intricate, and, most important, the clay was smooth and strong. She studied these shards and figured out how to match the clay and re-create the designs. The result was pottery that was as beautiful as that of her ancestors. Nampeyo began teaching her methods to others, and the Hopi Revival pottery movement was born.

Nampeyo also used traditional natural dye techniques to paint her pots with colors—*Sikyátki* means "yellow house" in Hopi and refers to this multicolor ceramic style. Many of the geometric designs on Nampeyo's ceramics are symbolic of significant stories in Hopi heritage and history. For example, an abstract geometric bird's wings reference the migration and movement of the Hopi people to their land. As Nampeyo's technique improved, she began to create her own unique designs and patterns.

The Santa Fe Railroad expanded to the Southwest about the same time that Nampeyo was making pottery. Tourists would stop at trading posts and purchase indigenous arts and crafts, which was a great source of income for many Native American communities. By age twenty, Nampeyo was a well-known ceramicist, and her notoriety grew as she traveled the country demonstrating her craft. Many indigenous women were creating artwork during this time period but Nampeyo was the most visible, and her name added extra value for curators and collectors. Artists such as Nampeyo and the expansion of transportation in the Southwest helped to spark a new interest in indigenous crafts throughout America and Europe.

In old age, Nampeyo began to lose her eyesight, but she continued to work. Her entire family would help paint her ceramics. In 1942, she passed away at the age of eighty-three, and her grandchildren and great-grandchildren continued her pottery dynasty.

IS OF BOTH TEWA AND HOPI DESCENT: BOTH HAVE INFLUENCED HER POTTERY.

HER TEWA NAME MEANS "SNAKE THAT DOES NOT BITE."

SHE TAUGHT CLASSES AT THE HOPI HOUSE AT THE GRAND CANYON.

SHE WAS THE MOST PHOTOGRAPHED CERAMICIST IN THE SOUTHWEST IN THE 1870s, STARTING WHEN WILLIAM HENRY JACKSON PHOTOGRAPHED HER IN 1875.

HER HUSBAND WORKED ON EXCAVATIONS, WHERE SHE MAY HAVE FOUND THE ANCIENT HOPI POTTERY THAT INSPIRED HER.

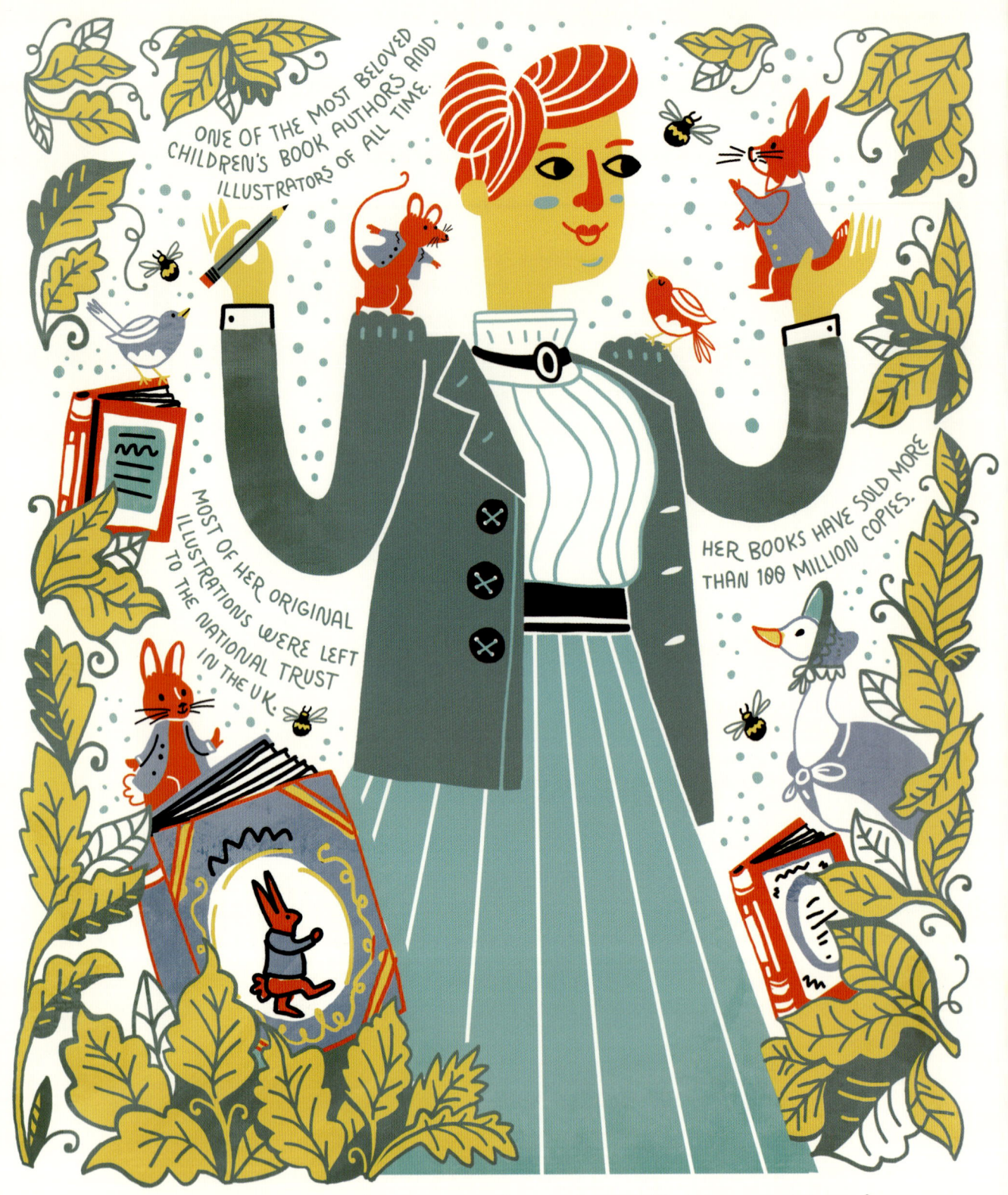

BEATRIX POTTER
AUTHOR AND ILLUSTRATOR (1866–1943)

CREATED AND SOLD A PETER RABBIT DOLL IN 1903.

SHE BRED SHEEP ON HER FARM, AND IN 1942 SHE BECAME PRESIDENT OF THE HERDWICK SHEEP BREEDERS' ASSOCIATION.

AFTER SHE DIED, SHE LEFT 16 FARMS AND 4,000 ACRES TO THE UK'S NATIONAL TRUST.

SHE HAS MANY OTHER FAMOUS CHARACTERS, SUCH AS MRS. TITTLEMOUSE AND JEMIMA PUDDLE-DUCK.

SHE WAS ALSO A NATURALIST WHO STUDIED AND DREW MUSHROOMS AND FUNGI.

Beatrix Potter was born in London in 1866. Her family was very wealthy, and Beatrix was raised by a governess. As a young girl in Victorian England, her childhood was strict and lonely. Beatrix loved nature and would fill her diaries with drawings from her trips to the Lake District and of her classroom pets. She and her brother would even sneak small animals into their house in paper bags.

In 1890, Beatrix began earning a small wage drawing illustrations for greeting cards. Beatrix also continued a correspondence with her childhood governess, Annie Moore. In these letters, she drew a little rabbit wearing clothes for Annie's children. Seven years later, this idea became her first book.

In 1900, Beatrix wrote, illustrated, and hand-bound her first book, *The Tale of Peter Rabbit*. It was filled with her dry wit and charming drawings. After being rejected by many publishers, she published the first edition herself in 1901. Soon, publisher Frederick Warne & Co. realized Peter Rabbit's potential and officially published it in 1902. Within one year, they printed six editions to keep up with the demand. Beatrix was a huge success! She continued to create many stories and drawings of tiny animals with big personalities, like *The Tale of Squirrel Nutkin* and *The Tale of Benjamin Bunny*.

Beatrix fell in love with her editor, Norman Warne. Her parents forbid her to marry him, claiming that a tradesman was below their social class. But Beatrix defied them, and she and Norman became engaged in 1905. A month later, he died of a blood disorder. Heartbroken, Beatrix decided to leave London for the country, to live the farm life of which she had always dreamed. She continued to publish stories inspired by the countryside. Beatrix loved nature and, with her book royalties, she purchased even more farmland. She began working with country solicitor William Heelis. The two fell in love and were married in 1913. Together they took care of their multiple farms and managed their massive estate.

Beatrix published her last major book, *The Tale of Little Pig Robinson*, in 1930. During her prolific career, she wrote more than twenty-eight books. Her stories and illustrations continue to be bedtime staples that delight children all over the world.

Elements and Principles of Art and Design

Art is a visual language that can sometimes transcend words. But with the right vocabulary, you can properly critique and express your ideas about art. Following are a few terms and design principles that illustrate the anatomy of art and design!

LINE

SHAPE

TEXTURE

SPACE
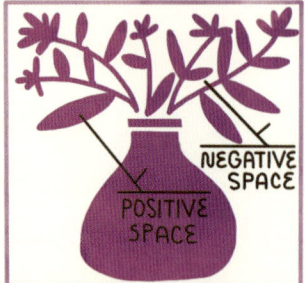

PATTERN

CONTRAST

EMPHASIS

BALANCE

RHYTHM/MOVEMENT

HARMONY

PROPORTION/SCALE

COLOR AND VALUE

COLOR WHEEL

PRIMARY — MADE OF ONE COLOR

SECONDARY — TWO PRIMARY COLORS MIX

- YELLOW — PRIMARY
- YELLOW-ORANGE — TERTIARY
- ORANGE — SECONDARY
- RED-ORANGE — TERTIARY
- RED — PRIMARY
- RED-PURPLE — TERTIARY
- PURPLE — SECONDARY
- BLUE-PURPLE — TERTIARY
- BLUE — PRIMARY
- BLUE-GREEN — TERTIARY
- GREEN — SECONDARY
- YELLOW-GREEN — TERTIARY

WARM COLORS / COOL COLORS

TERTIARY — SECONDARY AND PRIMARY COLORS MIX

TWO COMPLEMENTARY COLORS MIX TO MAKE BROWN

-CMYK-

COLOR MIXING WITH PIGMENT

YELLOW + MAGENTA = RED
YELLOW + CYAN = GREEN
MAGENTA + CYAN = BLUE
ALL = BLACK

-RGB-

COLOR MIXING WITH LIGHT

BLUE + RED = MAGENTA
BLUE + GREEN = CYAN
RED + GREEN = YELLOW
ALL = WHITE

COLOR SCHEMES

- ANALOGOUS
- COMPLEMENTARY
- SPLIT COMPLEMENTARY
- DOUBLE SPLIT COMPLEMENTARY
- PRIMARY
- SECONDARY
- TRIADIC
- MONOCHROMATIC

-VALUE-

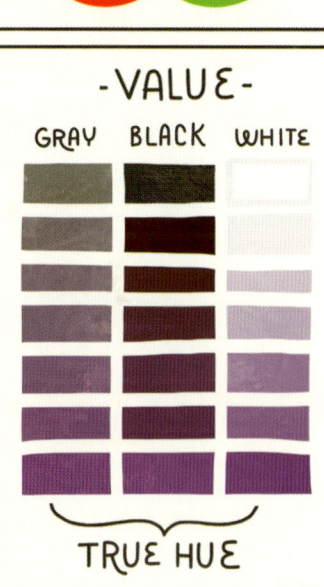

GRAY | BLACK | WHITE

TRUE HUE

35

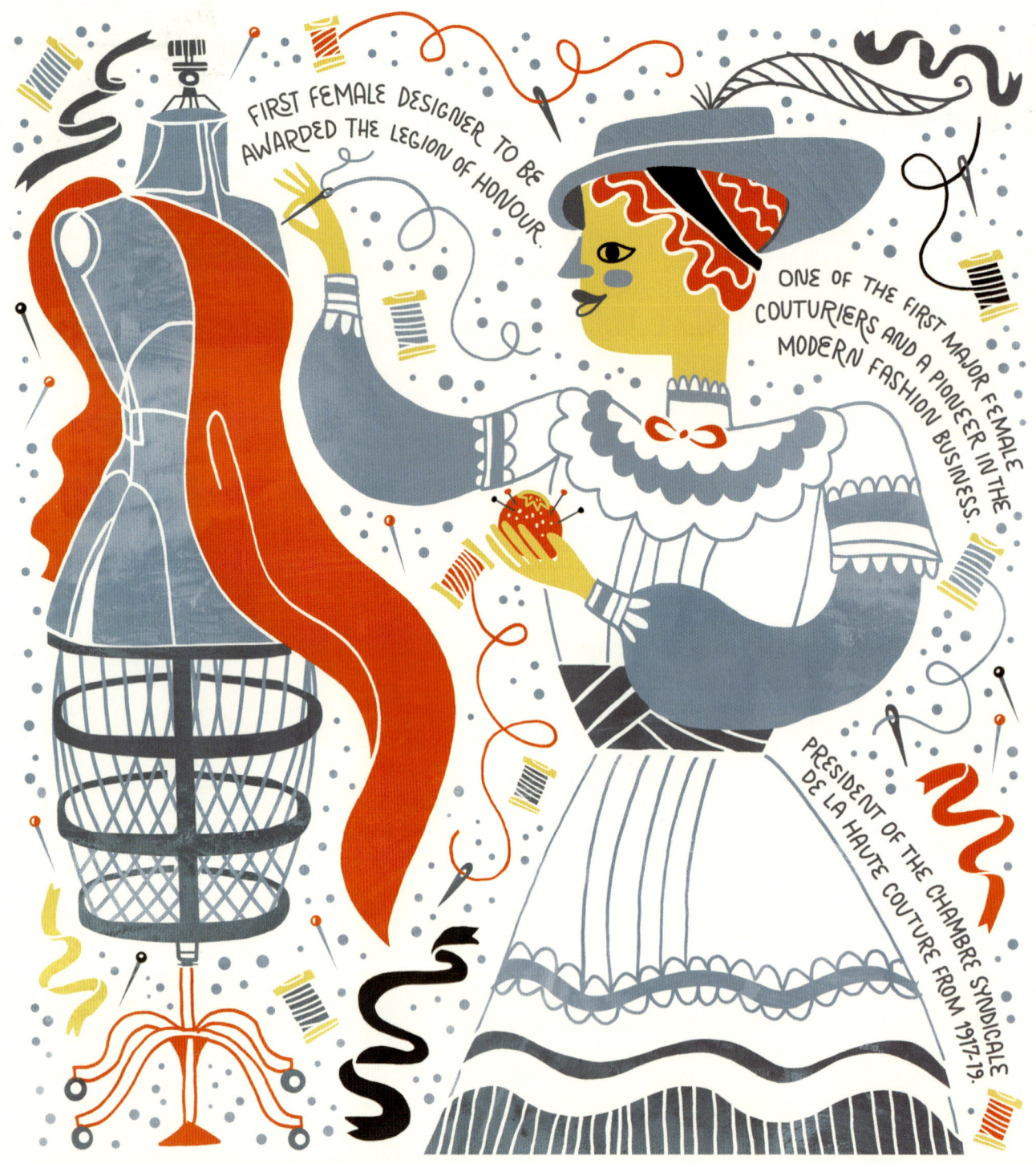

JEANNE PAQUIN
FASHION DESIGNER · (1869-1936)

For a long time, male designers dominated the Western fashion world, but this changed in the late 19th century with the rise of female fashion pioneers such as Jeanne Paquin. Unlike her male counterparts, Jeanne responded to the functional everyday needs of the modern woman, enabling her to build a fashion empire.

Jeanne was born in France in 1869. At fifteen, she began working as a dressmaker. Because of her sewing and design skills, she quickly became the *première*, or manager, of the studio. But Jeanne wanted to design clothes for her own fashion house. In 1891, she married Isidore René Jacob. Together they began the House of Paquin—he ran the business, and she was the head designer. In 1896, Paquin opened their first store in London, and in the year 1900, she was made the president of the fashion section of the Paris Universal Exhibition. The House of Paquin was a sensation.

In 1907, tragedy struck when Isidore died, and Jeanne became widowed at thirty-eight. Despite her grief, Jeanne threw herself into her work, continuing to run the fashion house and pushing herself as an artist. She was one of the first fashion designers to collaborate with architects, illustrators, painters, and people in the theater. She created elaborate fashion shows with full sets, including colorful wigs. Her unique shows were always sold out, despite the steep ticket price of $5 a seat (equivalent to more than $120 today).

Jeanne was one of the first European designers to focus on the functionality of women's fashion, prioritizing comfort and mobility in clothing. Jeanne wanted the women who wore her clothes to go seamlessly from a sporting event to a fancy party, without being inconvenienced or embarrassed by their outfits. In 1912, she began her own sportswear line for women, creating dresses for playing golf, motoring, and doing the tango! These were revolutionary new clothes for the modern woman.

In 1920, Jeanne retired, but her fashion house continued to run until 1956. Her ingenuity made her one of the most important and powerful couturiers of the early 20th century, and her beautiful garments inspired other designers to make the connection between function and style.

IN 1911, SHE DECORATED THE PAQUIN PAVILION TO LOOK LIKE A GREEK TEMPLE FOR THE TURIN WORLD'S FAIR.

I'M ON THE GO!

IN 1913, SHE DESIGNED A DRESS THAT IS CONSIDERED THE VERY FIRST "DAYTIME TO EVENING" OUTFIT.

HAUTE COUTURE MEANS "HIGH SEWING" AND DESCRIBES EXCLUSIVE, HANDMADE, AND UNIQUE HIGH-END GARMENTS.

AT THE PEAK OF THE PAQUIN HOUSE, JEANNE MANAGED MORE THAN 2,700 EMPLOYEES AND HAD STORES IN LONDON, NEW YORK, MADRID, AND BUENOS AIRES.

NOT JUST FOR MOURNERS ANY MORE!

BLACK IS THE NEW BLACK!

SHE MADE THE COLOR BLACK FASHIONABLE BY DRAPING DIFFERENT BLACK MATERIALS AND FABRICS IN PRETTY AND NEW WAYS.

DESIGNED MORE THAN 700 BUILDINGS IN CALIFORNIA AND HAWAII.

FIRST WOMAN TO BE AWARDED AN AIA GOLD MEDAL POSTHUMOUSLY IN 2014.

FIRST FEMALE ARCHITECT LICENSED IN CALIFORNIA.

"ARCHITECTURE IS A VISUAL ART, AND THE BUILDINGS SPEAK FOR THEMSELVES." —JULIA MORGAN

JULIA MORGAN
ARCHITECT · (1872-1957)

Julia Morgan was born in San Francisco in 1872. She became interested in architecture while attending the University of California, Berkeley. After graduating with a degree in civil engineering, Julia traveled to Paris in 1896. She wanted to study architecture at the École Nationale Supérieure des Beaux-Arts, but she was refused admission because the school did not accept women. This was not unusual for the time. Most universities, clubs, and meeting spaces were for men only. A group of Parisian female artists protested against the sexist universities, and this outcry forced the school to allow women to apply in 1897. Meanwhile, Julia studied for the difficult entrance exams for L'École. After taking the test three times, she finally became the first woman admitted into their architecture program. In 1902, she completed her studies and received her degree (twice as fast as the average student).

News of Julia's accomplishments traveled to the United States, and she was hired by architect John Galen Howard weeks after landing back in California. While working for John, Julia designed several buildings on the UC Berkeley campus, including the Hearst Greek Theatre. In 1904, she became the first woman to become licensed as an architect in California, and she opened her own office in San Francisco. Over the course of Julia's career, she would design more than 700 buildings. Her most important client was the wealthy Hearst family. They commissioned many of Julia's greatest buildings, like Hearst Castle.

During the early years of Julia's career, women across America were fighting for the right to vote. Julia designed one hundred buildings specifically with women in mind, like social and civic clubs, women's schools, housing for single women, and primary schools and orphanages for children. Julia would often charge lower commissions or sometimes even donate her labor for these important women's projects. In 1920, women gained the right to vote in the United States, but they still needed spaces to congregate and organize. By building spaces for women, Julia was directly fighting for a new progressive era. In 1950, Julia retired. She died seven years later. Today, many of her buildings are still in use and are known as architectural treasures.

SHE WORKED ON HEARST CASTLE FOR 28 YEARS AND WAS INVOLVED IN EVERY DETAIL, FROM PICKING OUT ANIMALS FOR THE ZOO TO THE POOL DESIGN TO THE PURCHASE AND PLACEMENT OF ART AND ANTIQUES IN THE HOME.

WORKED IN MANY ARCHITECTURAL STYLES, INCLUDING ARTS AND CRAFTS, SPANISH COLONIAL, TUDOR, AND GEORGIAN — DEPENDING ON WHAT MADE SENSE FOR A SPECIFIC LOCATION.

DESIGNED MANY YWCA BUILDINGS BETWEEN 1913 AND 1930.

HELPED TO REBUILD AND RESTORE MANY BUILDINGS AFTER THE 1906 SAN FRANCISCO EARTHQUAKE.

WHILE AT BERKELEY, SHE HELPED TO START A CHAPTER OF THE YWCA, FOUNDED SEVERAL WOMEN'S SPORTS TEAMS, AND WAS A MEMBER OF THE KAPPA ALPHA THETA SORORITY.

FOUNDED THE ANTHROPOPHAGY ART MOVEMENT.

CONSIDERED THE BIGGEST INFLUENCE ON MODERN ART IN BRAZIL.

WAS INSPIRED BY THE VIBRANT COLORS, PEOPLE, AND LANDSCAPES OF BRAZIL.

"I WANT TO BE THE PAINTER OF MY COUNTRY." —TARSILA DO AMARAL

TARSILA DO AMARAL
PAINTER · (1886-1973)

CABAPORU (1928).

ABAPORU MEANS "MAN EATS" IN TUPI-GUARANI, WHICH IS AN INDIGENOUS LANGUAGE OF BRAZIL.

SHE REJECTED THE MUTED COLORS OF WESTERN ART AT THE TIME AND WAS INSPIRED BY THE BRIGHT COLORS OF THE LANDSCAPES AND PAINTED BUILDINGS OF BRAZIL.

Tarsila do Amaral is the mother of modern art in Brazil. Tarsila was born in 1886 in São Paulo, Brazil. Her family was very wealthy, which allowed her to travel to Europe to study art in Paris at the Académie Julian in 1920. She traveled back to Paris in 1923 to continue her studies with avant-garde painters André Lhote, Albert Gleizes, and Fernand Léger. She learned about European modern art, cubism, and other avant-garde styles—which all bored her. She compared painting in these styles to "military service." Even the radical modern painters in Europe had strict rules about what was "proper" painting. Tarsila absorbed everything the European painting world had to offer, but when she returned to São Paulo, she took what she had learned and transformed it into a brand-new painting style.

Back in Brazil, the animals, landscape, people, and folk art inspired Tarsila. She began to blend the colors and imagery from her homeland with her formal Paris training, and she created an art movement called Antropofagia, which means "cannibalism." Tarsila believed that Brazilian artists should absorb, "eat," and learn from European art, with the intent to then break it down, "digest" it, and transform it into something new. In doing this, Tarsila created a modern art style that was uniquely Brazilian! In 1928, she created *Abaporu*, a painting that would define the cannibalism art movement. In *Abaporu*, she combined the very European subject matter of a nude woman bathing but abstracted her body to resemble the Brazilian landscape and mountains.

Tarsila became very successful in both São Paulo and Paris during the 1920s. Her art changed as the political and economic landscape of Brazil changed. During the Great Depression, she lost her personal wealth, and soon after, a military dictatorship took over Brazil. Tarsila continued her work, and her paintings became somber political statements.

Tarsila died in 1973 at the age of eighty-six. Her massive body of work consists of more than two hundred thirty paintings and hundreds of drawings, prints, and murals—all in her unique Brazilian style. She is the defining artist of her country.

SHE IS SO FAMOUS IN BRAZIL THAT SHE IS KNOWN BY JUST HER FIRST NAME.

A CUCA (1924).

SHE WAS VERY INFLUENCED BY INDIGENOUS BRAZILIAN ART.

THE AMARAL CRATER ON MERCURY IS NAMED AFTER HER.

CREATED ART FOR 70 YEARS.

HER ICONIC PAINTINGS ABSTRACTED NATURE LIKE NEVER BEFORE.

SHE IS A PIONEER OF AMERICAN 20TH-CENTURY MODERN ART.

"I FOUND I COULD SAY THINGS WITH COLOR AND SHAPES THAT I COULDN'T SAY ANY OTHER WAY— THINGS I HAD NO WORDS FOR." — GEORGIA O'KEEFFE

GEORGIA O'KEEFFE
PAINTER · (1887–1986)

Georgia O'Keeffe was born on a farm in Wisconsin in 1887. At ten years of age, she already knew she wanted to become an artist. She began her formal art training in 1905 at School of the Art Institute of Chicago and then transferred to the Art Students League of New York. In 1915, Georgia began creating rhythmic abstract charcoal drawings inspired by nature. Abstraction was still seen as radical in Europe, and she was one of the few artists to experiment with it in the United States. Georgia had found her voice as an artist.

One of Georgia's friends in New York showed these abstract drawings to famous photographer Alfred Stieglitz and he was very impressed. By 1917, Georgia had her first solo show in New York City in Alfred's gallery. Alfred and Georgia fell in love, and were married in 1924. Georgia became well known for her large close-up paintings of flowers. When she looked closely at a flower, she saw a colorful landscape, a whole world, and she wanted to share that beauty in her paintings. Critics, however, wanted only to talk about her romantic involvement with Alfred Stieglitz and to point out that her flowers looked like the female anatomy. Georgia was devastated that her paintings were misunderstood.

In 1929, she began her travels to New Mexico. Inspired by the beautiful Southwestern landscape and in part to break away from the criticism of her flowers, Georgia painted mountains, found animal bones, and the desert. She loved working outside, often painting through thunderstorms or in high heat. Her pioneering approach of abstracting nature into color studies continued to be a huge success.

Three years after Alfred's death in 1946, she moved to Santa Fe to live and work full-time at her home, Ghost Ranch. Georgia traveled the world selling and exhibiting her artwork and was inspired to paint the landscapes of Japan and Peru. In her old age, Georgia continued to create, hiking through the Nevada mountains as her young assistants struggled to keep up. At the age of ninety, her eyesight started to deteriorate but she continued to work, saying "I can see what I want to paint. The thing that makes you want to create is still there." In 1986, she died at age ninety-eight. Historians agree that she is one of the most important artists in history.

TURNED HER FORD MODEL-A INTO A MOBILE OUTDOOR STUDIO.

STARTED SCULPTING WHEN SHE LOST HER EYESIGHT IN OLD AGE.

MANY OF HER PAINTING SERIES STARTED AS A REALISTIC PAINTING THAT WOULD BECOME MORE AND MORE ABSTRACT WITH EACH CANVAS.

JIMSON WEED/ WHITE FLOWER NO. 1 (1932). GEORGIA SAID, "IF YOU TAKE A FLOWER IN YOUR HAND AND REALLY LOOK AT IT, IT'S YOUR WORLD FOR A MOMENT."

RECEIVED THE NATIONAL MEDAL OF ARTS IN 1985 FOR HER LIFETIME OF WORK.

THE CERRO PEDERNAL MESA WAS HER FAVORITE PLACE TO WORK. HER ASHES WERE SCATTERED THERE.

"I WISH TO BLUR THE FIRM BOUNDARIES WHICH WE SELF-CERTAIN PEOPLE TEND TO DELINEATE AROUND ALL WE CAN ACHIEVE." —HANNAH HÖCH

HANNAH HÖCH
COLLAGE ARTIST – MIXED MEDIUM (1889-1978)

Hannah Höch was the only woman who was part of the famous Dadaist group in Berlin, Germany. In response to the chaos, violence, and unprecedented loss of life during World War I, the Dada movement was antiwar, antiestablishment, and even anti-art! Dada artists used found objects and unconventional ways to make art that was deliberately irrational. Hannah is credited as one of the earliest artists to use photomontage (a collage made from photographs). She used her art to criticize the beauty standards, sexism, and racism of Weimar Germany.

Hannah was born in Gotha, Germany, in 1889. In 1912, she entered art school in Berlin, but her studies were interrupted by the start of WWI. She continued art school in 1915. While in school, she became romantically involved with Dada artist and writer Raoul Hausmann, who invited her to join the Berlin Dada art group. Although the male members of the Dada group maintained that they championed women's equality, they often excluded Hannah from their activities because she was a woman. They even tried to leave her out of the first International Dada Fair in 1920, until Raoul stood up for her. At this very art show, Hannah showed her piece *Cut with the Kitchen Knife Through the Last Weimar Beer-Belly Cultural Epoch in Germany* (1919). This photomontage would become Hannah's best-known work. It depicted female strength in the face of corporate corruption and sexism during postwar Germany.

In 1922, Hannah and Raul ended their relationship, and the Dadaist group soon broke apart. The politics in Germany set the stage for fascism, including widespread anti-Semitism, racism, and homophobia. Hannah continued to make art that challenged this bigotry. When the Nazi party took control in 1933, the government outlawed any art or literature with which they disagreed. In 1934, Hannah's art was considered "degenerate," and she was banned from exhibiting. Many of her peers fled Germany, but Hannah stayed in a cottage on the outskirts of Berlin. There, she continued to create art in isolation, while safekeeping her friends' works from being destroyed. Decades after WWII, Hannah's art was rediscovered and celebrated in museums all over the world. Hannah Höch continued to create art until her death in 1978.

WROTE ARTICLES ABOUT TEXTILES, KNITTING, CROCHETING, AND EMBROIDERY FOR A BERLIN MAGAZINE.

HER PHOTOMONTAGE *CUT WITH THE KITCHEN KNIFE THROUGH THE LAST WEIMAR BEER-BELLY CULTURAL EPOCH IN GERMANY* (1919),

INSTEAD OF SIGNING HER NAME IN THE BOTTOM RIGHT CORNER, SHE PUT A MAP OF THE COUNTRIES THAT HAD GIVEN WOMEN THE RIGHT TO VOTE.

SHE USED NEWSPAPERS, PRODUCT CATALOGS, AND MAGAZINE CLIPPINGS TO MAKE COLLAGES.

HANNAH WAS OPENLY BISEXUAL, HAD SHORT HAIR, AND OFTEN WORE MASCULINE CLOTHES—WHICH WAS UNUSUAL AND DANGEROUS IN EARLY-20TH-CENTURY GERMANY.

HER PHOTOMONTAGE SERIES CALLED *ETHNOGRAPHIC MUSEUM* (1924-1930) COMBINED IMAGES OF BODIES, SCULPTURES, AND MASKS FROM DIFFERENT PARTS OF THE WORLD.

HER MOST FAMOUS SERIES OF PAINTINGS ARE CALLED *EARTH AND SPACE*.

FIRST AFRICAN AMERICAN WOMAN TO HAVE A SOLO SHOW AT THE WHITNEY MUSEUM.

STARTED HER CAREER AS AN ABSTRACT PAINTER AT AGE SIXTY-NINE.

"TODAY NOT ONLY CAN OUR GREAT SCIENTISTS SEND ASTRONAUTS TO AND FROM THE MOON... BUT THROUGH THE MEDIUM OF COLOR TELEVISION, ALL CAN ACTUALLY SEE AND EXPERIENCE THE THRILL OF THESE ADVENTURES. THESE PHENOMENA SET MY CREATIVITY IN MOTION." —ALMA THOMAS

ALMA THOMAS
PAINTER · (1891–1978)

Alma Thomas was born in Georgia in 1891, the eldest of four daughters. In 1907, her family moved to Washington, DC, seeking better opportunities. As a young girl, Alma dreamed of becoming an architect. She entered Howard University to attend its newly created Fine Arts Program and, in 1924, graduated as the first person with a fine arts degree from Howard. That same year, she began her career as an art teacher at DC's Shaw Junior High School. While teaching, she continued to paint in a realistic style.

In 1960, Alma retired and devoted herself fully to painting. With a thirty-five-year teaching career behind her, she was determined to create a new body of work. Powering through bouts of painful arthritis in her wrists, she began to paint in vibrant color swatches, creating large abstract, rhythmic paintings.

Alma was inspired by how sunlight created colorful patterns in her home garden and by the rows of flowers planted throughout Washington, DC. For her *Earth* series, Alma created several abstract paintings of vibrantly patterned circles. *Earth* was a part of her 1966 retrospective show at Howard University. The show's success launched her career as an abstract painter.

Alma was also deeply inspired by the huge technological advances she witnessed in her lifetime. As she once said, "I was born at the end of the 19th century, horse-and-buggy days, and experienced the phenomenal changes of the 20th-century machine-and-space age." During the 1969 Apollo moon landing, she was awed by how the little colored dots of light on her television screen allowed her to see images directly from outer space. This inspired her famous *Space* series of paintings, which included works titled *Apollo 12 "Splash Down"* (1970) and *Starry Night and the Astronauts* (1972).

Alma's paintings captivated audiences all over America. In 1972, she became the first black woman to have a solo show at The Whitney. Before Alma Thomas passed away in 1978, she received many honors and national praise. In the final eighteen years of her life, Alma painted her most exciting and important body of work, proving that it is never too late to try something new and create something beautiful.

THE *EARTH* PAINTING SERIES WAS COMPARED TO BYZANTINE MOSAICS.

SNOOPY SEES EARTH WRAPPED IN SUNSET (1970) IS NAMED AFTER THE SNOOPY LUNAR MODULE FROM THE APOLLO 10 MISSION.

RECEIVED A MASTER OF ARTS DEGREE FROM COLUMBIA UNIVERSITY IN 1934.

PAINTINGS *WATUSI (HARD EDGE)* (1963), *SKY LIGHT* (1973), AND *RESURRECTION* (1966) ALL HUNG IN THE WHITE HOUSE DURING THE OBAMA ADMINISTRATION.

RESURRECTION IS NOW PART OF THE PERMANENT WHITE HOUSE COLLECTION.

FIRST DIRECTOR OF THE HARLEM COMMUNITY ART CENTER.

STOOD UP TO INJUSTICE AND RACIAL DISCRIMINATION THROUGHOUT HER CAREER.

AN IMPORTANT ARTIST OF THE HARLEM RENAISSANCE.

"IF I CAN INSPIRE ONE OF THESE YOUNGSTERS TO DEVELOP THE TALENT I KNOW THEY POSSESS, THEN MY MONUMENT WILL BE IN THEIR WORK. NO ONE COULD ASK FOR MORE THAN THAT." —AUGUSTA SAVAGE

AUGUSTA SAVAGE
SCULPTOR AND TEACHER · (1892-1962)

Augusta Savage was born in Florida in 1892. She always knew she wanted to become an artist even though her Methodist minister father thought making art was a sin. Augusta used to sculpt animals from red clay she found in the ground. When caught by her father, she was disciplined harshly. At age fifteen, Augusta married, and she had her only child a year later. In 1919, Augusta was given some clay by a local potter. Finally, with access to materials, she was able to sculpt large figures and won a local competition. To further her art career, she moved to New York City with only $4.60 in her pocket. In 1921, Augusta received a full scholarship to The Cooper Union.

In 1923, Augusta was selected to study at a prestigious summer program at the Fontainebleau School of the Fine Arts in France. Once she had arrived, the school revoked her invitation upon seeing the color of her skin. Outraged by this discrimination, Augusta petitioned the Ethical Culture Committee, and she was written about in American papers. Sadly, the program still denied her entry. After she completed her studies at Cooper Union, Augusta worked in a steam laundry to support herself and to send money back to her family. She began getting commissions sculpting busts and portraits of African American heroes, and she soon became known as one of the only sculptors to exclusively depict people of African descent. In 1929, she sculpted the bust of a young boy called *Gamin*, (which means "street urchin" in French). This small sculpture put her artwork on the map, and she was awarded a Julius Rosenwald fellowship; at last, she was officially funded to study in Paris. Augusta soon won a Carnegie Foundation grant and traveled all over Europe.

Augusta returned to New York in 1932 during the Great Depression. She noticed that African Americans were being left out of opportunities created by the Works Progress Administration (WPA), which was a massive government program that, among other things, employed artists to create public art. She fought to make sure black artists were being hired and that black history was being depicted in government-funded murals. Augusta helped create the Harlem Community Art Center in 1937 and was its first director. She believed her true legacy would be her teaching art to others. Augusta died in 1962, and today she is known as a hero of the Harlem Renaissance.

IN 1931, SHE RECEIVED A CARNEGIE FOUNDATION GRANT TO TRAVEL AND LEARN IN FRANCE, BELGIUM, AND GERMANY FOR EIGHT MONTHS.

16 FEET TALL
SHE CREATED THE SCULPTURE CALLED *THE HARP* FOR THE NEW YORK WORLD'S FAIR IN 1939. IT WAS INSPIRED BY JAMES WELDON JOHNSON'S POEM "LIFT EVERY VOICE AND SING."

IN 1932, AUGUSTA FOUNDED THE SAVAGE STUDIO OF ARTS AND CRAFTS IN HARLEM.

IN 1934, SHE BECAME THE FIRST AFRICAN AMERICAN ELECTED TO THE NATIONAL ASSOCIATION OF WOMEN PAINTERS AND SCULPTORS.

SHE SCULPTED BUSTS OF AFRICAN AMERICAN HEROES SUCH AS W.E.B. DU BOIS.

IS IN THE NATIONAL WOMEN'S HALL OF FAME.

HER WORK CHANGED DOCUMENTARY AND JOURNALISTIC PHOTOGRAPHY FOREVER.

CAPTURED IMPORTANT MOMENTS IN AMERICAN HISTORY IN HER PHOTOS.

"SEEING IS MORE THAN A PHYSIOLOGICAL PHENOMENON... WE SEE NOT ONLY WITH OUR EYES BUT WITH ALL THAT WE ARE AND ALL THAT OUR CULTURE IS. THE ARTIST IS A PROFESSIONAL SEE-ER." —DOROTHEA LANGE

DOROTHEA LANGE
PHOTOGRAPHER (1895-1965)

One of the most important documentary photographers of all time, Dorothea Lange was born in 1895 in New Jersey. In 1919, she opened a portrait studio in San Francisco. During her career, Dorothea would capture many important moments in American history with her camera.

During the Great Depression, millions of people across the United States lost their jobs. Dorothea took photographs of the breadlines and the worker demonstrations happening in her city. Her work was shown in a public exhibition, including the photograph *White Angel Breadline* (1933). These photographs led to Dorothea being hired by the Resettlement Administration in 1935 (later called the Farm Security Administration [FSA]). For the FSA, she would travel the country and photograph the migrant workers moving west to escape the dust bowl. The dust bowl was an agricultural crisis in the 1930s that exasperated the Great Depression. A long drought, combined with bad farming practices in the Midwest, caused the soil to become unusable. To escape starvation and poverty, many families packed up all their belongings and began driving to California. Dorothea's photographs were some of the very first to chronicle the effects of the dust bowl. She showed the rest of America the severity and desperation of the situation without sacrificing the dignity or humanity of her subjects.

During World War II, the Japanese military attacked Pearl Harbor and the US government forced American citizens of Japanese ancestry into internment camps. In 1942, Dorothea began documenting life in these camps, showing families and children being put into detention centers. These images were quickly censored by the US Army, but today, these photos are publicly available and used to accurately portray this shameful moment in US history.

In 1945, Dorothea became very ill from recurring polio. Despite pain and exhaustion, she continued to work and travel all over the world. Near the end of her life, she began preparing a retrospective of her life's work for a solo show at the Museum of Modern Art (MoMA). In 1965, Dorothea passed away at the age of seventy; her retrospective opened the next year. Dorothea Lange presented empathy and truth in each of her photographs, and she helped turn documentary photography into an art form.

SHE TRAVELED TO ASIA, THE MIDDLE EAST, AND SOUTH AMERICA TO TAKE PHOTOS.

HER PHOTOS OF THE DUST BOWL WERE USED AS INSPIRATION FOR THE MOVIE ADAPTATION OF *THE GRAPES OF WRATH*.

SHE WORKED ON SEVERAL PHOTO ESSAYS FOR *LIFE* MAGAZINE.

WAS THE 6TH PHOTOGRAPHER AND THE 1ST FEMALE PHOTOGRAPHER TO HAVE A SOLO SHOW AT THE MoMA.

THE PHOTOGRAPH *MIGRANT MOTHER* (1936) HAS BECOME THE ICONIC IMAGE OF THE DUST BOWL.

THE BOOK *IMPOUNDED: DOROTHEA LANGE AND THE CENSORED IMAGES OF JAPANESE AMERICAN INTERNMENT* WAS PUBLISHED IN 2008.

HELPED CREATE SYNTHETIC FIBERS AND WEAVING TECHNIQUES FOR MACHINE-MADE FABRICS.

HER TEXTILES HAVE BEEN USED BY ARCHITECTS AND INTERIOR DESIGNERS.

CALLED "THE MOTHER OF MODERN WEAVING."

"PROBABLY THE GREATEST WEAVER ALIVE TODAY, FOR SHE HAS BROADENED TEXTILE HORIZONS AS NO ONE BEFORE HER." —*HOUSE & GARDEN* MAGAZINE

DOROTHY LIEBES
TEXTILE DESIGNER, WEAVER, AND BUSINESS WOMAN · (1897-1972)

Dorothy Liebes was born in California in 1897. She studied education, anthropology, and art at San Jose State Teacher's College and at the University of California, Berkeley. One of Dorothy's professors thought her paintings looked like weavings, so Dorothy began teaching herself how to weave on a small, portable hand loom. In 1920, Dorothy studied weaving at Hull House in Chicago. Throughout her career, she would travel the globe, to Mexico, Guatemala, Italy, and France, to learn different kinds of traditional weaving techniques.

In 1934, Dorothy started her own textile company in San Francisco. As her business grew, she hired other weavers and expanded to open a second studio in New York City. In 1948, she closed her first office and completely relocated her business to New York City.

Dorothy's textiles were bright and playful and often used unusual materials such as metallic fibers, leather, sequins, and even ticker tape. Her swatches looked like precious pieces of colorful modern art, which were then manufactured on a large scale to create fabrics. Dorothy's textiles were used to cover the floors and walls of major buildings throughout America, and she worked with famous architects, like Frank Lloyd Wright and Edward Durell Stone. Her major commissions included making fabric for the dining room at the United Nations, the Persian Room at the Plaza Hotel, and custom textiles for the traveling royal throne room for the king of Saudi Arabia.

Dorothy was the color and design consultant to major chemical companies such as DuPont, Dow, and Bigelow Carpets. They wanted to manufacture synthetic fibers, and, with her weaving experience, Dorothy made sure their fabric looked and felt the right way. She even made sure the machines creating the fabric could duplicate the irregularities and happy accidents that occur when fabrics are handwoven. She wanted to make sure the human touch wasn't lost just because machines were doing the weaving.

Many of the fabrics used today were influenced by Dorothy. She helped to bring an ancient craft into the modern era. She continued to run her business for the rest of her life, semi-retiring in 1971 only because of a heart condition. One year later, she passed away. Today, she is known as "the mother of modern weaving."

SHE USED UNCONVENTIONAL MATERIALS SUCH AS GLASS RODS, BAMBOO, GRASS, AND WIRE IN HER WEAVINGS.

HER DESIGNS WERE FEATURED IN MANY MAJOR MUSEUMS, INCLUDING THE MoMA.

TODAY HER WORK IS HELD IN MANY COLLECTIONS, INCLUDING THAT OF THE COOPER HEWITT, SMITHSONIAN DESIGN MUSEUM.

SHE WAS THE DIRECTOR OF DECORATIVE ARTS FOR THE 1939 SAN FRANCISCO WORLD'S FAIR.

DURING WORLD WAR II, SHE TAUGHT INJURED SOLDIERS HOW TO WEAVE AS PART OF THE RED CROSS'S ART THERAPY PROGRAM.

SHE RECEIVED THE AMERICAN CRAFT COUNCIL GOLD MEDAL IN 1970.

THE QUINTESSENTIAL ARTIST OF THE ART DECO ERA.

PAINTED NUDES AND THE GLITZY ELITE DURING THE ROARING TWENTIES.

COMBINED CUBISM WITH A NEOCLASSICAL STYLE TO CREATE HIGHLY STYLIZED AND POLISHED PAINTINGS.

"I LIVE LIFE IN THE MARGINS OF SOCIETY, AND THE RULES OF NORMAL SOCIETY DON'T APPLY TO THOSE WHO LIVE ON THE FRINGE." — TAMARA DE LEMPICKA

TAMARA DE LEMPICKA
PAINTER · (1898-1980)

Tamara de Lempicka was born in 1898 in Warsaw in what was then part of the Russian Empire. Her family was very wealthy, but all that would change during Russia's violent revolution in 1917. Her family fled, but Tamara and her husband, Tadeusz Lempicki, refused to leave St. Petersburg. Soon, Tadeusz was taken by the police, and Tamara had to negotiate his safe return from prison. They soon immigrated to Paris. Tadeusz became too depressed to work, and Tamara gave birth to their daughter. Faced with poverty, Tamara decided that she would provide for her family by using her natural talent for painting.

Tamara began her art studies at Académie de la Grande Chaumière in 1918. In 1925, her paintings had been accepted into major art shows in Milan and Paris, and she was getting attention from magazines such as *Harper's Bazaar*. Tamara's art was born from the glamorous world of the 1920s. Like the art deco designs and buildings of the era, her paintings were smoothly polished, highly decorative, and, above all, celebrated new technology and wealth. She painted beautiful models and the ultra-rich elite upper-class of Europe and the United States. Her subjects would often stand towering over a backdrop of skyscrapers, exuding power. Tamara's work became hugely popular and her main patron was the wealthy Dr. Pierre Boucard. With him as a client, Tamara became wealthy herself. She purchased a custom-designed house, threw extravagant parties, and wore the finest jewels and furs. Just as she created scenes of lavishness in her paintings, Tamara made sure her public persona fit in with this era of decadence.

In 1928, Tadeusz and Tamara divorced, and in 1934, she married Baron Raoul Kuffner. In 1939, Tamara took a trip to visit friends in Germany. Tamara was half-Jewish, and she was disturbed by the anti-Semitism she saw, and how different Germany was under the Nazis. She convinced her husband that they needed to leave Europe and move to the United States. Tamara continued to paint, but her art career began to fade into obscurity. She was rediscovered and, in 1973, the Luxembourg Gallery in Paris held a retrospective of her work. Her art deco paintings were a roaring success! She passed away in 1980. Today, her paintings are still collected by posh people and celebrities.

WAS HEAVILY INFLUENCED BY HER MENTOR ANDRÉ LHOTE, WHO PAINTED IN THE "SYNTHETIC CUBIST" STYLE.

AUTOPORTRAIT PAINTED IN 1929 IS TAMARA'S BEST-KNOWN WORK.

MADONNA FEATURED TAMARA'S PAINTINGS IN MANY OF HER MUSIC VIDEOS.

CLAIMED THAT SHE WOULD PAINT FOR 9 HOURS AT A TIME, ONLY STOPPING FOR CHAMPAGNE, A MASSAGE, AND A BATH.

PORTRAIT OF THE DUCHESS OF LA SALLE (1925).

SHE WAS OPENLY BISEXUAL AND PAINTED GAY PUBLIC FIGURES, LIKE DUCHESS DE LA SALLE AND ANDRÉ GIDE.

CONSIDERED ONE OF THE MOST IMPORTANT AMERICAN SCULPTORS.

CONSIDERED THE FIRST ARTIST TO CREATE LARGE-SCALE SCULPTURES ENTIRELY FROM FOUND OBJECTS.

WAS AWARDED THE NATIONAL MEDAL OF ARTS IN 1985.

"I THINK CUTTING BACK ON THE ARTS DOESN'T ONLY MEAN CUTTING BACK ON THE ARTS, IT MEANS CUTTING BACK ON CIVILIZATION." — LOUISE NEVELSON

LOUISE NEVELSON
SCULPTOR · (1899 -1988)

HER ART WAS SHOWCASED AT THE 31ST VENICE BIENNALE.

Black Wall (1959) LOUISE CALLED HER WALL ART "ENVIRONMENTS" BECAUSE THEY INVITED THE VIEWER TO GET LOST IN THE MONOCHROMATIC TEXTURE, SPACE, AND DEPTH.

Dawn's Wedding Feast (1959) WAS HER FIRST WHITE "ENVIRONMENT."

Louise Nevelson was born in 1899 in Russia, and in 1905, her family immigrated to the United States. Growing up in Maine, young Louise always knew that she would one day become famous. In 1920, she married the wealthy owner of a shipping business, Charles Nevelson, and they moved to New York City. Two years later, Louise had her only child. She and Charles separated in 1931.

While in New York, Louise studied opera, performing arts, and painting. She dedicated herself to a life in the arts, even though it meant struggling to make ends meet. She had many odd jobs, including working as an extra in a German film in 1931 and assisting Diego Rivera on his mural at Rockefeller Plaza in 1933. In 1941, Louise had her first solo show at the Nierendorf Gallery in New York. Although Louise worked as a serious artist and showed her work in many galleries, it took thirty years before she sold her first artwork.

In the 1950s, Louise began creating the work that would make the art history books. She would comb the streets collecting scrap wood and used this found "junk" to create sculptures. She layered wooden crates, old bedposts, and moldings to make her large-scale, wall-size "environments." She would then paint them her favorite color, black. Louise loved the color black, explaining that "it contained all color. It wasn't a negation of color. It was an acceptance. Because black encompasses all colors." She would also sometimes create pieces in all white or in gold. In 1958, Louise exhibited her first wall-piece, called *Sky Cathedral*. In the winter of 1958-59, she showed her new sculptures at the MoMA in New York. It was a breakthrough moment in her career, and critics celebrated her "command of darkness and deep shadow," remarking that her sculptures "open an entire realm of possibility." Louise became a sensation!

Louise was in her sixties when she was finally able to support herself by just making art. After many shows in world-renowned museums, she had a major retrospective at the Whitney Museum of American Art in New York in 1967. Louise continued to create work and to win awards up until her death in 1988. Her sculptures and wall hangings can be seen in public spaces and prestigious galleries all over the United States.

HER FATHER OWNED A LUMBERYARD, AND LOUISE OFTEN PLAYED WITH WOOD SCRAPS AS A CHILD.

SHE WORKED WITH STEEL, PLEXIGLASS, AND ALUMINUM LATER IN LIFE.

I GOT CHUTZPAH!

GROWING UP, SHE SPOKE YIDDISH AT HOME WITH HER FAMILY.

STATISTICS · IN · ART

Although females make up nearly half of the population and now comprise a majority of art school students, there is still an inequity in how women are treated in the professional art world. Following are statistics that show the disparity in representation, pay, and power in the fine arts.

AUCTION

HIGHEST-SELLING ARTWORKS BY MALE ARTISTS

SOLD IN 2017 FOR $450.3 MILLION

SALVATOR MUNDI BY LEONARDO DA VINCI (CIRCA 1500)

SOLD IN 2015 FOR $300 MILLION

INTERCHANGE BY WILLEM DE KOONING (1955)

SOLD IN 2011 FOR AN ESTIMATED $250 MILLION

THE CARD PLAYERS BY PAUL CÉZANNE (1892)

HIGHEST-SELLING ARTWORKS BY FEMALE ARTISTS

SOLD IN 2014 FOR $44.4 MILLION

JIMSON WEED/ WHITE FLOWER NO. 1 BY GEORGIA O'KEEFFE (1932)

SOLD IN 2015 FOR $28.2 MILLION

SPIDER BY LOUISE BOURGEOIS (1996)

SOLD IN 2014 FOR $11.9 MILLION

UNTITLED BY JOAN MITCHELL (1960)

THE 2016 GENDER GAP IN ART MUSEUM DIRECTORS

These are statistics from the Association of Art Museum Directors (AAMD) and the National Center for Arts Research 2017 report.

LARGE MUSEUMS (BUDGETS OF MORE THAN $15 MILLION)

- 70% of museum directors are male
- 30% of museum directors are female

In 2016, female directors made **75 CENTS** for every dollar a male director made.

SMALL MUSEUMS (BUDGETS OF LESS THAN $15 MILLION)

- 46% of museum directors are male
- 54% of museum directors are female

In 2016, female directors made **98 CENTS** for every dollar a male director made.

THE GUERRILLA GIRLS—STATISTICS MAKE STATEMENTS

Tired of the gender inequality in the art world, the Guerrilla Girls, an anonymous group of female artists, decided to turn statistics into art activism! One of their most famous works was a series of billboards showing the gender inequity at New York's Metropolitan Museum of Art, where they counted how many female artists were represented versus how many nude female bodies were on display. All over the world, the Guerrilla Girls have organized female artists and created projects that fight for gender equality in the arts.

We wear gorilla masks whenever we appear in public!

According to the Guerrilla Girls' survey of the Metropolitan Museum of Art (The Met)

Percentage of nude artwork on display at The Met that is of nude women:
- 1989: 85%
- 2005: 83%
- 2012: 76%

Percentage of art in The Met's modern art section made by female artists:
- 1989: 5%
- 2005: 3%
- 2012: <4%

59

BESTOWED THE PERSONAL RECOGNITION AWARD FROM THE INDUSTRIAL DESIGNERS SOCIETY OF AMERICA IN 1994.

CREDITED AS THE FIRST PROMINENT FEMALE INDUSTRIAL DESIGNER.

ONE OF THE FIRST INDUSTRIAL DESIGNERS TO EXPERIMENT WITH PLASTICS.

"DESIGN DIDN'T JUST HAPPEN. IT HAD TO BE DEVELOPED. I FELT THAT IT WAS WONDERFUL, LIKE A PUZZLE, ALL THE PARTS FITTED IN: THE BUSINESS TRAINING, PAINTING, COLOR STUDY, AND MY INTEREST IN MECHANICS, MACHINERY, AND PRODUCTION PROBLEMS." —BELLE KOGAN

BELLE KOGAN
INDUSTRIAL DESIGNER · (1902–2000)

Belle Kogan was born in 1902 in Russia and immigrated to the United States with her family at the age of four. Belle grew up in Allentown, Pennsylvania, with seven siblings. During her senior year in high school, she took a class in mechanical drawing and found her calling in industrial design. She first used these skills to teach a class in technical drawing while saving money to go to college. After graduation, she attended Pratt Institute in Brooklyn, but in 1920, she had to leave after only one semester because times were tough for the Kogan family. She had to help her family and worked in her father's jewelry store. Belle began designing jewelry settings while taking classes at the Art Students League of New York whenever she had time.

In the late 1920s, Belle had a chance meeting with the head of the Quaker Silver Company. He was impressed with her design skills, and she began freelancing for the company, designing objects in silver and pewter. Her skills in technical drawing allowed Belle to draw sketches for clients that were completely functional and ready to be mass-produced. Around 1931, Belle opened her own studio in New York City. At the time, industrial design was run by men, and many manufacturers would not work with a woman. Belle recalled one machine shop in Ohio that, assuming she was a man, accepted her designs by mail but refused to do business with her once they saw her in person. She described these first years as "cruelly discouraging."

Despite those early challenges, Belle became known for her smart geometric plastic table sets, whimsical clocks, and stylish Bakelite jewelry. She understood that women were being ignored by male designers, stating, "thirty million women—all potential customers, constituting practically the entire buying structure of the nation—comprise a force which cannot or should not be disregarded." By 1939, her business was booming, and Belle was able to hire three female designers to work for her.

Belle's designs and smart business skills made her the first female industrial designer in the United States and a leader among her peers. In the late 1930s, she was a founding member of the New York chapter of the American Designers Institute (ADI). She died in 2000 and is remembered as a pioneer in the field of design.

"I BELIEVE THAT GOOD DESIGN SHOULD KEEP THE CONSUMER HAPPY... ...AND THE MANUFACTURER IN THE BLACK."

SHE MADE SURE HER DESIGNS WERE EQUALLY BEAUTIFUL, FUNCTIONAL, AND COST EFFECTIVE FOR HER MANUFACTURING PARTNERS.

BAKELITE WAS THE FIRST PLASTIC CREATED FROM SYNTHETIC MATERIALS, AND BELLE WAS ONE OF THE FIRST DESIGNERS TO WORK WITH IT.

HER STUDIO HAD MANY MAJOR CLIENTS, LIKE RED WING POTTERY, LIBBEY GLASS, AND REED & BARTON.

SHE DESIGNED THE "QUACKER" DUCK CLOCK FOR THE COMPANY TELECHRON.

BELLE DID MANY INTERVIEWS, LECTURES, AND TV APPEARANCES.

AN IMPORTANT PHOTOGRAPHER IN DOCUMENTING LIFE DURING THE POST-REVOLUTION MEXICAN RENAISSANCE.

ONE OF MEXICO'S FIRST FEMALE PROFESSIONAL PHOTOGRAPHERS.

THE STREET PHOTOGRAPHY FROM HER FIFTY-YEAR CAREER DOCUMENTED THE PEOPLE AND "HEART" OF MEXICO.

"IF MY PHOTOGRAPHS HAVE ANY MEANING, IT'S THAT THEY STAND FOR A MEXICO THAT ONCE EXISTED." —LOLA ÁLVAREZ BRAVO

LOLA ÁLVAREZ BRAVO
PHOTOGRAPHER (1903-1993)

Lola Álvarez Bravo was born in Mexico in 1903 (though her birth year has also been recorded as 1907). At a young age, her parents separated and she moved with her father from a small city in Jalisco to large and bustling Mexico City. When she was eight, Lola's father passed away, leaving her to be raised by relatives. In her neighborhood, she made friends with Manuel Álvarez Bravo. They fell in love and were married in 1925. Manuel was a professional photographer, and Lola began her career by working as his assistant in the darkroom. Lola was inspired by photographers Edward Weston and Tina Modotti and would often use Manuel's camera equipment to take her own photos. After Manuel and Lola separated in 1934, she began taking photos professionally to support herself and her seven-year-old son.

In the mid-1930s, Lola had a chance to photograph Mexico's minister of education. He was so impressed with her work that he showed her photos to everyone! Soon Lola was hired by *El Maestro Rural* (*The Rural Teacher*) magazine and became chief photographer. She documented everything from schools and orphanages to farms and fire stations for the magazine. During a time in Mexico when female artists were expected to stay in the studio, Lola was capturing life outdoors as it happened. She recalls that "I was the only woman fooling around with a camera in the streets and all the reporters laughed at me. So I became a fighter." For the next fifty years, Lola worked doing professional portraits, photojournalism, and commercial photography, but her personal projects would be her best work. In 1944, she had her first solo exhibition. In many of Lola's photos, like *En Supropiacárcel* (1950), she used dramatic contrast of light and shadow. She said, "[I captured] images that affected me deeply, like electricity, and made me press the shutter; and not only with a great artistic sense, or great beauty and light and all, but also with a sense of humor, with that sort of playfulness that is so Mexican. . . ." Lola wanted to show "the heart" of Mexico.

Lola continued to take photos until she lost her eyesight in 1982 at the age of seventy-nine. She passed away in 1993. Her massive collection of photos now graces the walls of many major museums, and all can see the slice of Mexican history that Lola Álvarez Bravo immortalized with her camera.

WORKED AS THE DIRECTOR OF PHOTOGRAPHY AT THE NATIONAL INSTITUTE OF FINE ARTS IN MEXICO CITY.

OPENED AND OPERATED HER OWN GALLERY FROM 1951 TO 1958, WHICH HOSTED FRIDA KAHLO'S ONLY SOLO SHOW IN MEXICO.

COMPUTADORA 1 (1954).

LOLA ALSO EXPERIMENTED WITH PHOTOMONTAGE (COLLAGE).

SHE ORGANIZED TRAVELING PHOTOGRAPHY EXHIBITIONS TO RURAL AREAS THAT DID NOT HAVE ACCESS TO GALLERIES.

PHOTOGRAPHED MANY FAMOUS ARTISTS, INCLUDING FRIDA KAHLO.

DREAM OF THE POOR (1949).

LOLA USED HER PHOTOS TO INSPIRE COMPASSION FOR IMPOVERISHED PEOPLE AND THOSE AFFECTED BY THE VIOLENCE OF THE RECENT MEXICAN REVOLUTION.

...WAS THE OFFICIAL UNITED STATES CULTURAL AMBASSADOR TO AFRICA IN 1970.

...PAINTED IN MANY DIFFERENT STYLES DURING HER LONG CAREER.

...WAS INFLUENCED BY FRENCH IMPRESSIONISM PAINTING, HAITIAN ART, AND AFRICAN MOTIFS AND DESIGNS.

"MINE IS A QUIET EXPLORATION—A QUEST FOR NEW MEANINGS IN COLOR, TEXTURE, AND DESIGN. EVEN THOUGH I SOMETIMES PORTRAY SCENES OF POOR AND STRUGGLING PEOPLE, IT IS A GREAT JOY TO PAINT." —LOÏS MAILOU JONES

LOÏS MAILOU JONES
PAINTER, DESIGNER, AND TEACHER · (1905-1998)

DESIGNED ABSTRACT FABRIC PATTERNS FOR SEVERAL TEXTILE COMPANIES BEFORE BECOMING AN ART PROFESSOR.

JULY 29, 1984, LOÏS JONES DAY WAS DECLARED IN WASHINGTON, D.C.

TAUGHT MANY OTHER FAMOUS ARTISTS, LIKE ALMA THOMAS, ELIZABETH CATLETT, AND DAVID DRISKELL.

Loïs Mailou Jones was born in 1905 in Boston to a middle-class family. Her parents recognized that their daughter was very talented and encouraged her artwork. She graduated from the School of the Museum of Fine Arts in Boston in 1927 and continued her education at several universities. In 1930, she was recruited by Howard University, where she taught as an art professor for forty-seven years.

In the early 1930s, Loïs experimented with realistic portraiture and created vibrant, stylized artwork that celebrated the Harlem Renaissance. Despite her talent, she was not afforded the same opportunities as white artists. Segregation laws allowed schools and businesses to exclude African Americans, and many black artists moved abroad, tired of their talent not being recognized in the United States. In 1937, Loïs took a sabbatical year in Paris. While in Paris, Loïs was inspired by the impressionists, and painted the city streets and the French countryside. Her art was received with wild enthusiasm. At the time, European artists were heavily influenced by African tribal art. Loïs was already familiar with African masks and featured them in her masterpiece, *Les Fétiches* (1938).

Loïs returned to the United States with a new body of exciting work, but she still experienced discrimination. Her artwork would be accepted into galleries, but once they realized she was black they refused to display her work. So Loïs began covertly mailing her artwork to museums and galleries so it would be shown. She recalled going to galleries where the attendees were completely unaware that she had painted the art hanging on the walls.

Because of the struggle and progress of the civil rights movement in the 1950s and 1960s, black artists, including Loïs, were able to achieve more recognition. In 1970, the US Information Agency made Loïs the official cultural ambassador to Africa, enabling her to teach, lecture, and visit museums in eleven African nations. Loïs also took many trips to Haiti with her husband, Haitian artist Louis Vergniaud Pierre-Noel. Loïs was moved by the art of both Africa and Haiti and her painting evolved to incorporate bright patterns and abstract shapes.

Throughout Loïs's lifelong career, she received many awards and honors. Loïs Mailou Jones is remembered as a pioneer who fought against the racism of the art establishment, and by doing so, she created space for other black artists.

HER WORK IS IN THE PERMANENT COLLECTIONS OF THE MET, THE SMITHSONIAN, THE NATIONAL PALACE IN HAITI, THE NATIONAL MUSEUM OF AFRO-AMERICAN ARTISTS, AND MANY OTHER MUSEUMS.

UBI GIRL FROM TAI REGION (1972) WAS ONE OF MANY IMPORTANT PAINTINGS INSPIRED BY HER TRIPS TO AFRICA.

CREATED SURREALIST PHOTOGRAPHS WITH MAN RAY.

WAS A WAR CORRESPONDENT DURING WORLD WAR II.

PUBLISHED SOME OF THE FIRST IMAGES EXPOSING THE CONCENTRATION CAMPS OF THE HOLOCAUST.

"NATURALLY I TOOK PICTURES, WHAT'S A GIRL SUPPOSED TO DO WHEN A BATTLE LANDS IN HER LAP?" —LEE MILLER

LEE MILLER
PHOTOGRAPHER · (1907-1977)

Elizabeth "Lee" Miller was born in New York in 1907, and she became interested in photography as a young child. While attending the Art Students League of New York, she was saved from being struck by an oncoming streetcar by none other than Condé Nast! He was the owner of *Vogue* magazine, and he introduced Lee to its editor in chief, Edna Woolman Chase. Edna was looking for the next "modern girl" and put Lee on the cover of *Vogue* in March 1927, making her one of the most in-demand fashion models in the late 1920s.

In 1929, Lee left New York and headed to Paris, where surrealist artists were creating some of the strangest images anyone had ever seen. Lee went to Man Ray's studio and asked him to teach her the mysteries of surrealist photography. Together, they discovered new photographic techniques, contorting the human body and using props to create impossible dreamlike situations. Lee often modeled in front of the camera. In 1932, Lee moved back to New York and established a successful portrait studio. Never one to stay put for long, Lee left New York for Cairo and lived in Egypt for three years, where she took many photography expeditions across the desert.

At the beginning of World War II in 1939, Lee was living in London. She witnessed the German bombing, and instead of fleeing she leaped into the chaos with a helmet on her head and a camera in her hands. She worked as an official war correspondent for *Vogue* and captured the real-life surrealism during wartime Britain. In 1942, she was accredited as a US forces war correspondent and photographed the war and its aftermath until 1946. She documented the liberation of Paris and many battles throughout Germany. When the Americans arrived at Buchenwald and Dachau, Lee was one of the first photographers to document the horrors of the concentration camps and the genocide of the Jewish people. Her work helped to expose the Holocaust to the public.

After the war, Lee had her only child with her husband, Roland Penrose. She occasionally worked as a photographer into the 1970s but suffered from post-traumatic stress disorder (PTSD) from the war. In her later years, she became a gourmet chef and cooked elaborate feasts for her many friends. Lee Miller passed away in 1977, leaving behind an enormous amount of work that is still being discovered.

IN 1941, HER PHOTOS OF EGYPT WERE DISPLAYED AT THE MoMA IN NEW YORK.

DURING THE 1970s, HER HOME IN THE ENGLISH COUNTRYSIDE WAS VISITED BY HER FRIENDS AND MANY FAMOUS ARTISTS, LIKE PABLO PICASSO, MAX ERNST, AND MAN RAY.

WHEN THE ALLIED INVASION OF EUROPE CAME IN 1944, LEE WAS THE ONLY WOMAN PHOTO-JOURNALIST ON THE FRONT LINE.

WAS A SURREALIST GOURMET COOK, MAKING MEALS SUCH AS GREEN CHICKEN, MARSHMALLOWS IN A COLA SAUCE, AND HUGE ELIZABETHAN FEASTS.

"I PAINT MY OWN REALITY. THE ONLY THING I KNOW IS THAT I PAINT BECAUSE I NEED TO, AND I PAINT WHATEVER PASSES THROUGH MY HEAD WITHOUT ANY OTHER CONSIDERATION." —FRIDA KAHLO

FRIDA KAHLO
PAINTER · (1907-1954)

HER WORK CELEBRATED HER HERITAGE, AND WAS INSPIRED BY MEXICAN FOLK ART AND RELIGIOUS VOTIVE PAINTINGS.

SHE MADE MORE THAN 140 PAINTINGS, A THIRD OF WHICH WERE SELF-PORTRAITS

THE TWO FRIDAS (1939).

THIS PAINTING EXPLORED TWO SIDES OF HER PERSONALITY, SYMBOLIZED BY WEARING EUROPEAN AND TRADITIONAL TEHUANA CLOTHES.

DIEGO AND FRIDA WERE NICKNAMED THE ELEPHANT AND THE DOVE.

IN 1950, SHE GOT GANGRENE IN HER FOOT AND HAD TO AMPUTATE HER LEG. SHE WORE A PROSTHETIC.

FOR HER MEXICO CITY SHOW, FRIDA LAY IN A BED THAT SHE DECORATED WITH MIRRORS AND PHOTOS OF HER FAMILY, FRIENDS, AND HEROES.

Frida Kahlo was born on July 6, 1907, in a small town near Mexico City. At the age of six, she contracted polio, which caused permanent damage to her right leg. Despite this, Frida grew up playing sports and even wrestling. She enjoyed drawing, but she focused her studies on science and medicine. At the age of eighteen, she was horribly injured in a violent bus crash and her life would change forever. Doctors had to put her in a full-body cast, and Frida would be stuck in a hospital for months. To help pass the time, Frida's family built her a special easel that allowed Frida to paint while lying down in bed. This is when she realized that she wanted to devote her life to art. Throughout her life, Frida experienced chronic pain and endured countless surgeries. Frida turned her emotional and physical pain into the inspiration for some of the world's most beautiful paintings.

After her recovery, Frida became a member of the Mexican Communist party in 1927; and the next year, she met famous muralist Diego Rivera. They were married in 1929, becoming one of the most famous couples in Mexico: Diego was known for his politics and art, while Frida was mostly known for just being his wife. Frida continued her political work and art, even though she was not acknowledged at first. Diego and Frida had a complicated and often difficult relationship and the pain and joy of their love was a major subject in Frida's work. Frida also created many self-portraits that explored her identity as a woman. In these works, she unapologetically rejected Western beauty standards and celebrated her own indigenous mestiza heritage. This is seen in her choice of clothes, her beautiful unshaven face, and the use of Mexican iconography and symbolism.

Her artwork began to receive recognition in 1938, when she had her first successful solo show in New York. A year later, the Louvre bought one of her paintings. Over the next decade, her art career was on the rise, but her health continued to decline. In 1953, she finally had a solo show in Mexico City. Too sick to stand in the gallery, Frida laid in a bed to receive guests. The next year, she died at the age of forty-seven. Today, her paintings are celebrated and shown all over the world, and Frida's name has become a rallying cry for feminism.

FIRST WOMAN TO JOIN THE ART DIRECTORS CLUB IN NEW YORK.

FIRST FEMALE ART DIRECTOR OF A MASS-MARKETED AMERICAN PUBLICATION.

ART DIRECTOR FOR THE MAGAZINES GLAMOUR, SEVENTEEN, CHARM, AND MADEMOISELLE.

"WE TRIED TO MAKE THE PROSAIC ATTRACTIVE WITHOUT USING THE TIRED CLICHÉS OF FALSE GLAMOUR. YOU MIGHT SAY WE TRIED TO CONVEY THE ATTRACTIVENESS OF REALITY, AS OPPOSED TO THE GLITTER OF A NEVER-NEVER LAND." —CIPE PINELES

CIPE PINELES
GRAPHIC DESIGNER AND ART DIRECTOR · (1908–1991)

Cipe Pineles was born in Vienna in 1908. At the age of thirteen, her family immigrated to Brooklyn, New York, but she would keep her thick Austrian accent throughout her life. Cipe graduated from the Pratt Institute in 1929 and was hired by design company Contempora in 1931. Condé Nast, founder and head of the namesake magazine and media empire, was interested in the retail displays that Cipe created at Contempora. He was so impressed that he hired her as a designer for *Vogue* and *Vanity Fair*.

Cipe worked as an assistant for demanding art director Mehemed Fehmy Agha. An art director oversees the visual styling and look of a magazine by making sure all of the designers', illustrators', and photographers' work is cohesive to their vision. Agha trained Cipe in how to become a great editorial designer. Cipe recalled that "Agha was the most fabulous boss to work for. Nothing you did satisfied him. He was always sending you back to outdo yourself, to go deeper into the subject." In 1942, Cipe was promoted and became the art director for *Glamour*.

In 1947, Cipe became the art director for *Seventeen* magazine. At the time, most magazines with young female audiences treated their readers as mindlessly obsessed with marriage. But *Seventeen* was different. The founder, Helen Valentine, wanted to educate young women and provide them with role models. Cipe created sophisticated modern designs to match the content that ambitious young girls deserved. Cipe went on to become the art director of both *Charm*, "the magazine for women who work," and *Mademoiselle*. With these magazines, she was able to advance the image of the independent woman.

Throughout Cipe's career, she was a respected art director who won many awards, and she served on the board for the American Institute of Graphic Arts (AIGA). Despite this, the Art Directors Club (ADC) of New York refused to allow a female member. It took a protest from her husband (also a graphic designer) for them to change their minds. The ADC made Cipe its first female member in 1948, and in 1975, Cipe was inducted into the ADC hall of fame. Cipe Pineles continued to contribute to the design community until her death in 1991. In 1996, she was posthumously awarded the AIGA medal for her outstanding sixty-year career.

ALSO WORKED FOR *VOGUE* MAGAZINE IN NEW YORK AND LONDON (1932–38).

WAS A GRAPHIC DESIGN CONSULTANT FOR LINCOLN CENTER FROM 1961 TO 1972.

WON AN ART DIRECTORS CLUB GOLD MEDAL FOR HER ILLUSTRATIONS AND LAYOUT FOR AN ARTICLE ABOUT COOKING POTATOES.

BEGAN TEACHING AT PARSONS SCHOOL OF DESIGN IN 1963.

COMMISSIONED FAMOUS ARTISTS, LIKE ANDY WARHOL AND AD REINHARDT, TO ILLUSTRATE FOR *SEVENTEEN*, WHICH BROUGHT MODERN ART TO ITS YOUNG READERS.

IN 1945, SHE WROTE AND ILLUSTRATED A COOKBOOK OF JEWISH RECIPES.

THE MANUSCRIPT WAS REDISCOVERED AND THE BOOK, *LEAVE ME ALONE WITH THE RECIPES*, WAS PUBLISHED IN 2017.

DESIGNED THE IT'S A SMALL WORLD DISNEYLAND RIDE.

CONCEPT ARTIST FOR THE WALT DISNEY STUDIOS.

HER ART INFLUENCED MANY CLASSIC MOVIES SUCH AS ALICE IN WONDERLAND, CINDERELLA, AND PETER PAN.

"YOU GET AN EDUCATION IN SCHOOL AND IN COLLEGE. AND THEN YOU START TO WORK. AND THAT'S WHEN YOU LEARN!" —MARY BLAIR

MARY BLAIR
ILLUSTRATOR, DESIGNER, CONCEPT ARTIST, AND ANIMATOR · (1911-1978)

The Walt Disney Studios has made some of the most iconic animated films in modern history. Behind the scenes of each of these films are hundreds of talented animators and concept artists, and one of the most enduring and influential was Mary Blair. Born in Oklahoma in 1911, Mary graduated from the Chouinard Art Institute in Los Angeles in 1933, with the hopes of becoming a traditional painter. When she left college, the Great Depression had cooled the high-end art world, and Mary needed to find commercial work. Mary began working as an animator in Hollywood and, in 1940, she joined Walt Disney Studios.

The next year, Mary journeyed on a Disney-funded art retreat to South America. The colors and patterns that Mary saw on her travels inspired her. She began creating very stylized illustrations. Her work was playful, and many said that her paintings felt as if you were seeing the world through the eyes of a child. Walt Disney himself was so impressed by Mary's art that he named her art supervisor for cartoons *The Three Caballeros* and *Saludos Amigos*. Her fresh and modern style made her one of Walt's favorite artists. Her concept paintings heavily impacted the character designs, camera angles, and emotional use of color in many Disney movies. Her influence is especially seen in *Alice in Wonderland*, *The Adventures of Ichabod and Mr. Toad*, *Cinderella*, and *Peter Pan*.

After the completion of *Peter Pan* in 1953, Mary left Disney Studios to pursue a freelance career. She painted children's book illustrations, created ads for Maxwell House Coffee, and designed window displays for luxury department stores such as Bonwit Teller in New York. In 1964, Walt Disney commissioned Mary for a special assignment: to design "a salute to the children of the world," the famous attraction, It's a Small World. On this ride, originally made for the 1964 New York World's Fair, passengers board an actual boat that travels through scenes from different countries. Mary designed each of the dancing animatronic characters, sculptures, and murals that give the ride its toy-like charm. All over the world, Disney theme parks still feature the It's a Small World ride, and visitors wait in line for hours just to experience its magic. Although Mary Blair worked decades ago, her whimsical artwork continues to stay relevant. Her legacy continues to influence illustrators and films today.

HER CONCEPT ART WAS USED IN MANY DISNEY SHORT FILMS, LIKE *SUSIE THE LITTLE BLUE COUPE* AND *THE LITTLE HOUSE*.

HER HUSBAND, LEE BLAIR, WAS ALSO AN ARTIST WHO WORKED AT DISNEY.

SHE PAINTED MANY MURALS FOR DISNEYLAND ATTRACTIONS, INCLUDING THE GRAND CANYON CONCOURSE AT THE CONTEMPORARY RESORT AND THE TOMORROWLAND PROMENADE.

ILLUSTRATED MANY GOLDEN BOOKS, INCLUDING *THE UP AND DOWN BOOK* AND *I CAN FLY*.

WAS THE COLOR DESIGNER ON 1967 FILM *HOW TO SUCCEED IN BUSINESS WITHOUT REALLY TRYING*.

IN 2009, THE TOKYO MUSEUM OF CONTEMPORARY ART DISPLAYED THE FIRST LARGE-SCALE EXHIBIT OF HER WORK.

WORKED ON WPA MURALS AND CREATED POLITICAL WORKS.

COMBINED DANCE, PAINTING, AND MUSIC TO CREATE PERFORMATIVE EXPERIENCES.

HER PAINTINGS WERE INSPIRED BY HER AFRICAN AMERICAN HERITAGE AND THE FOLK ART SHE SAW ON HER TRAVELS.

"THE WORK OF THELMA JOHNSON STREAT IS IN MY OPINION ONE OF THE MOST INTERESTING MANIFESTATIONS IN THIS COUNTRY AT THE PRESENT." —DIEGO RIVERA

THELMA JOHNSON STREAT
▷▷▷▷▷▷▷▷▷▷ PAINTER, DANCER, AND EDUCATOR (1911-1959) ◁◁◁◁◁◁◁◁◁◁

Thelma Johnson Streat was born in Washington state and grew up in Portland, Oregon. After studying at the University of Oregon in the mid-1930s, she traveled America. She spent time in New York, Chicago, and San Francisco, where she began working on large-scale murals for the Works Progress Administration (WPA). Through this work, she befriended Mexican muralist Diego Rivera and assisted on his *Pan American Unity* mural in 1939—she was one of the few people he allowed to actually paint on his mural.

In 1940, Diego wrote Thelma a letter of introduction to galleries, in which he praised her work as "extremely evolved and sophisticated enough to reconquer the grace and purity of African and Indian American art." This letter led to the acceptance of her painting *Death of a Black Sailor* (1943) to be displayed in a Los Angeles gallery. After World War II, African American veterans who had risked their lives defending the United States were coming home to a country that still denied them basic civil rights. Thelma's painting pointed out this hypocrisy while honoring the men who had been lost. The Ku Klux Klan (KKK), a violent white supremacist group, did not like Thelma's *Sailor* painting and threatened her and the gallery. Thelma would not be intimidated. Both she and the gallery refused to take down her painting, and it proudly remained on display for the rest of the exhibition.

Thelma often worked with themes of African American history but she also created many abstract paintings inspired by her travels throughout Europe, Mexico, Haiti, and Hawaii. Her other passion besides painting was dance! Thelma was one of the first artists to incorporate dancing into her gallery presentations by performing rhythmic interpretations in front of her paintings. In 1947, Thelma became one of the few African American abstract artists to have a solo show in New York.

In 1959, Thelma's career was sadly cut short when she died of a heart attack at the age of forty-seven. For almost sixty years, her artwork was mostly forgotten, but was returned to the forefront in 2016 when her painting *Medicine and Transportation* (1942-44) went on display as part of the permanent collection in the Smithsonian. Thelma Johnson Streat is now celebrated as she was during her lifetime, as a great artist and activist.

CELEBRITIES, LIKE FANNY BRICE AND VINCENT PRICE, COLLECTED HER PAINTINGS.

SHE OPENED A SCHOOL IN HONOLULU AND WORKED WITH HER HUSBAND, JOHN EDGAR, TO PROMOTE RACIAL EQUALITY THROUGH ART EDUCATION.

SHE WAS BIGGER THAN LIFE!

HER FAMILY CONTINUES TO CHAMPION HER WORK AND TO MAKE SURE IT IS SEEN BY THE PUBLIC.

IN 1942, SHE WAS THE FIRST FEMALE AFRICAN AMERICAN ARTIST TO HAVE WORK COLLECTED BY THE MoMA.

"AN ARTIST CAN SHOW THINGS THAT OTHER PEOPLE ARE TERRIFIED OF EXPRESSING." —LOUISE BOURGEOIS

LOUISE BOURGEOIS
SCULPTOR, INSTALLATION ARTIST, PAINTER, AND PRINT MAKER · (1911-2010)

Louise Bourgeois was born in 1911 in Paris. Her family owned a gallery that featured beautiful antique tapestries. As a child, Louise was always drawing, and would help her mother with tapestry repairs. In 1930, Louise entered the Sorbonne and began studying mathematics. Two years later, her mother passed away; this sparked Louise to change her major and to pursue her passion for art. Louise's father disapproved and refused to finance her art education. To continue her studies, Louise translated classes for American students in exchange for free tuition. In 1935, she graduated from the Sorbonne and continued her art studies in Paris. In 1938, she married American art historian Robert Goldwater, and together they moved to the United States.

In 1945, Louise had her first solo show in New York City, where she showed twelve paintings. Soon after, her work was included in the Whitney Annual. In 1949, she had her first solo sculpture show of her series *Personages* (1945-55), which are surreal, human-size wooden and stone totems. Her work would often warp or distort the human form. Over the next thirty years, she created sculptures, paintings, and prints—no medium or material was off-limits to Louise. Her art has been described as "psychologically charged" and deals with pain, anger, and the need for protection from a scary world. Despite her prolific body of work, Louise was unknown to the general public. But that would all change after the 1982 retrospective of her work at the Museum of Modern Art, which showed one hundred works that Louise had created over her long art career. One of the stand-out pieces included her room-size installation, made of latex and wood, called *Destruction of the Father* (1974). Finally, at the age of seventy, she became an international sensation.

At the age of eighty, she began creating her famous *Spider* series. These large, fierce, and fragile-looking metal spiders represented her mother, who like a spider had been a creative and industrious weaver. To Louise, spiders were both predator and protector from pests. In 1999, she titled her largest spider, which is 30 feet tall, *Maman*. Her spiders have been shown all over the world, from Kansas City and St. Petersburg to Buenos Aires and Paris. In 1997, Louise was awarded the National Medal of Arts. During the last twenty years of her life, she became one of the most respected and influential artists in the world.

WAS GIVEN AN HONORARY DOCTORATE FROM YALE IN 1977.

IN 1973, SHE BEGAN TEACHING CLASSES AT MANY ART SCHOOLS IN NEW YORK.

IN 1989, SHE STARTED HER SCULPTURAL SERIES CALLED *CELLS*, WHICH ARE INSTALLATIONS OF CAGED ROOMS FILLED WITH SCULPTURES AND FOUND OBJECTS.

HONORED BY THE NATIONAL WOMEN'S HALL OF FAME IN 2009.

REPRESENTED THE UNITED STATES AT THE 1993 VENICE BIENNIAL.

30 FEET TALL

FOR THE OPENING OF THE TATE MODERN IN 2000, SHE INSTALLED *MAMAN* (1999) AND *I DO, I UNDO, AND I REDO* (1999-2000)

"I NEVER GAVE UP PAINTING, I JUST CHANGED MY PALETTE." — RAY EAMES

RAY EAMES

INDUSTRIAL DESIGNER, GRAPHIC ARTIST, ARCHITECT, AND FILMMAKER (1912-1988)

"We wanted to make the best for the most for the least" was the motto of Charles and Ray Eames, the power couple that created the Eames studio. Ray Eames was born Bernice Kaiser in Sacramento, California, in 1912. She started her career as a painter and studied with famous abstractionist Hans Hofmann. In 1940, she met Charles Eames at Cranbrook Academy of Art in Michigan. Charles and architect Eero Saarinen were trying to create a chair out of a new material called plywood. Molding brittle plywood into complex curves was tricky. Ray helped them prepare their chair for display at the MoMA's Organic Design in Home Furnishings competition. Although they won the first two prizes, their design was impossible to mass-produce.

Ray and Charles fell in love and were married in 1941. Soon after, they opened their own design studio in Los Angeles. Together, Ray and Charles continued to design a plywood chair for mass production. Function completely lead the design process and they constantly tested and re-tested the materials and how the sitter felt in the chair. In 1946, the Eames Lounge Chair was finally mass-produced. Critics called it "the chair of the century." This was only the start. People returning home from World War II were excited to start fresh with new homes. The Eames' studio created molded plastic and plywood furniture lines for the new middle-class suburban lifestyle. The studio's continued success with furniture allowed them to take on other kinds of projects. They created toys such as House of Cards (1952), and produced movies such as *The Powers of Ten* (1968, released in 1977).

Throughout Ray and Charles's partnership, Charles got most of the credit. During the 1950s, interviewers depicted Ray as his "little helper," not as the equal partner she was. Charles protested this by saying, "Anything I can do, Ray can do better." Ray was involved in every project and their collaboration was completely intertwined. Ray was especially known for her use of color and whimsy. She also created the textiles and graphic art for the studio and styled and art directed the iconic Eames' advertisements and photographs.

Charles passed away in 1978 and during the last decade of her life, Ray led the studio. In the 1980s, she was fully recognized as a design genius. She passed away in 1988. Today "Eames" has become synonymous for the entire era of mid-century design.

DURING WORLD WAR II THE EAMESES DESIGNED SPLINTS MADE OUT OF PLYWOOD.

THE EAMESES DESIGNED THEIR OWN HOME, THE *EAMES HOUSE*, ALSO KNOWN AS CASE STUDY HOUSE #8 (1949), WHICH HAS BECOME ONE OF THE MOST IMPORTANT PIECES OF ARCHITECTURE IN THE 20TH CENTURY.

THE EAMES LOUNGE CHAIR (1946) IS PART OF THE PERMANENT COLLECTION AT THE MoMA.

STUDIO 901 IN VENICE, CA, WAS THE EAMESES' OFFICE FROM 1943 TO 1988.

SHE LOVED KNICKKNACKS AND CLUTTER, AND HER COLLECTIONS FILLED HER HOME AND OFFICE.

"FREEDOM IS NOT GIVEN TO YOU, YOU HAVE TO SEIZE IT." —MÉRET OPPENHEIM

MÉRET OPPENHEIM
SURREALIST SCULPTOR · (1913-1985)

Méret Oppenheim's sculptures are as iconic of the surrealist movement as Salvador Dali's melting clocks or Man Ray's glass tears. The surrealist art movement of the 1930s was all about dreams, the unconscious mind, and a person's deepest desires. The movement was male-dominated, and women were almost exclusively used as models or portrayed as muses and objects of desire. But Méret's sculptures explored the strict gender roles and oppression of women in society while also exploring female identity.

Méret was born in Germany in 1913. As World War I began, her family fled to Switzerland. In 1932, Méret moved to Paris, where she met surrealist photographer Man Ray and began working as his model. The next year, Méret became part of the surrealist movement as an artist on her own. Her sculptures juxtaposed normal, everyday items with disturbing or humorous materials or imagery.

Her sculpture *Object* (1936; also known as *Luncheon in Fur*), was a teacup, saucer, and spoon that were completely covered in fur. She turned a delicate and domestic item into something that looked like an animal, tapping into the viewer's subconscious—many couldn't help but imagine the discomfort of drinking out of a wet, furry teacup. In 1936, her sculpture was featured in a show at the MoMA called "Fantastic Art, Dada, Surrealism." *Object* was such a success that she gained overnight fame. Her other sculptures also combined materials and objects in strange ways, like her sculpture *My Nurse* (1936), which was a pair of women's high heels bound like a cooked chicken. The same year, Méret had her first solo exhibition at Galerie Schulthess in Basel, Switzerland.

Méret became overwhelmed by the sudden fame and success, and stopped making art for the next twenty years. In the mid-1950s, she became inspired to create again. In 1956, she designed the costumes for a production of Picasso's play *Le Désir attrapé par la queue* (*Desire Caught by the Tail*). In her studio in Switzerland, she began writing, sculpting, and designing costumes and jewelry. In 1967, Méret was recognized with a large retrospective in Stockholm.

In 1982, Méret Oppenheim was awarded the Grand Art Prize from the city of Berlin. After a career making art that tapped into the subconscious to expose unspoken truths, Méret passed away in 1985.

SHE TOOK A SELF-PORTRAIT WITH AN X-RAY MACHINE: *X-RAY OF MÉRET OPPENHEIM'S SKULL* (1964).

DESIGNED *THE SPIRAL COLUMN* (1983) AS A FOUNTAIN FOR THE PUBLIC SQUARE IN BERN, SWITZERLAND.

CREATED SURREAL GARMENTS SUCH AS *PAPER JACKET* (1976) AND *PAIR OF GLOVES* (1985).

THE IDEA FOR *OBJECT* (1936) CAME FROM JOKING WITH OTHER ARTISTS OVER LUNCH ABOUT MÉRET'S FUR BRACELETS. MÉRET SAID SHE COULD COVER ANYTHING WITH FUR, EVEN A TEACUP, AND JOKED ALOUD...

"WAITER, MORE FUR!"

THE GOVERNMENT OF INDIA HAS DECLARED HER WORKS AS NATIONAL ART TREASURES.

DEPICTED THE LIVES OF INDIAN WOMEN AND THE PLIGHT OF IMPOVERISHED PEOPLE.

COMBINED WESTERN AND INDIAN INFLUENCES TO DEVELOP A COMPLETELY UNIQUE PAINTING STYLE.

"I CAN ONLY PAINT IN INDIA. EUROPE BELONGS TO PICASSO, MATISSE, BRAQUE... INDIA BELONGS ONLY TO ME." —AMRITA SHER-GIL

AMRITA SHER-GIL
PAINTER (1913-1941)

Amrita Sher-Gil was born in 1913, in Budapest, Hungary. Her mother was Jewish Hungarian, and her father was an Indian Sikh. At a young age, Amrita showed natural talent in art. She began formal art lessons at the age of eight, after her family moved to northern India. At sixteen, Amrita sailed back to Europe with her mother to start her formal painting education in Paris, where she attended the Académie de la Grande Chaumière and the École des Beaux-Arts. In Paris, she was influenced by post-impressionist painters Paul Cézanne, Paul Gauguin, and Amedeo Modigliani. At the young age of nineteen, Amrita won the 1933 gold medal at the Grand Salon in Paris for her painting *Young Girls* (1932). Despite Amrita's success in Paris, she felt a need to leave, stating that she was "haunted by an intense longing to return to India, feeling in some strange inexplicable way that there lay my destiny as a painter." She traveled to India at the end of 1934 and began her tour throughout the country. She was inspired by the stylized art found in the Ajanta Caves and by the vibrancy and composition found in 17th-century Mughal miniatures. She began blending the Western techniques she had been taught in Paris with these Indian influences to create her own style of painting.

Amrita was also deeply moved by the people of India. She was determined to depict the everyday lives and emotions of impoverished people, as she did in her painting *Village Scene* (1938). She also wanted to reflect the private world of Indian women and the intimate bonds that women share. During this time, it was common for many male Indian painters to depict women as happy and submissive. Amrita on the other hand wanted to show the complicated and silent emotions of women. In her painting *Three Girls* (1935), she shows three dignified young women sitting, waiting for a future they cannot control.

In 1938, Amrita returned to Hungary to marry Victor Egan, and together they moved back to India. She lived in the village of Saraya and later in Lahore. In 1941, she became ill just a few days before her first major solo exhibition and passed away at the young age of twenty-eight. She created a huge body of work during her lifetime and made an even larger impact on the art world. Today, she is regarded as a pioneer and one of India's most influential modern artists.

UNESCO, THE CULTURAL ORGANIZATION OF THE UNITED NATIONS, DECLARED 2013, THE 100TH ANNIVERSARY OF HER BIRTH, THE INTERNATIONAL YEAR OF AMRITA SHER-GIL.

HER MOM WAS AN OPERA SINGER, AND HER DAD WAS A SCHOLAR OF PERSIAN AND SANSKRIT.

SOUTH INDIAN VILLAGERS GOING TO MARKET (1937) WAS PAINTED DURING HER TRAVELS THROUGH THE SOUTH OF INDIA.

IN 2006, HER PAINTING VILLAGE SCENE SOLD FOR 6.9 CRORE RUPEES (ABOUT $973,000), A RECORD-BREAKING AMOUNT PAID FOR A PAINTING IN INDIA.

"I HAVE ALWAYS WANTED MY ART TO SERVICE MY PEOPLE—TO REFLECT US, TO RELATE TO US, TO STIMULATE US, TO MAKE US AWARE OF OUR POTENTIAL." —ELIZABETH CATLETT

ELIZABETH CATLETT
SCULPTOR AND PRINTMAKER · (1915-2012)

AS A LEFT-WING ACTIVIST, SHE UNDERWENT INVESTIGATION BY THE US HOUSE UN-AMERICAN ACTIVITIES COMMITTEE DURING THE McCARTHY ERA IN THE 1950s.

SHE SCULPTED BUSTS OF MARTIN LUTHER KING JR. AND WRITER PHILLIS WHEATLEY, AND SHE ETCHED SCENES OF HARRIET TUBMAN.

Elizabeth Catlett was born in 1915 and raised by her mother in a middle-class neighborhood in Washington, DC. Her father had passed away before Elizabeth was born. While growing up, Elizabeth's grandmother shared stories about her own experience as a slave and the hardships she had faced. Elizabeth was saddened by these stories and became angered when she realized just how inaccurately the films of the time depicted slavery. When Elizabeth was ready to go to college, she earned a scholarship to the Carnegie Institute of Technology. Unfortunately, once the school realized she was black, they denied her entrance. Instead, Elizabeth went to Howard University, where she graduated from the art department with honors in 1935 and went on to earn her MFA from the University of Iowa.

In 1946, Elizabeth received a grant from the Rosenwald Foundation to create art in Mexico City. During her time there, she met muralists and political activists who believed that art was for everyone and a tool to uplift the people. Elizabeth recalled her time at the Taller de Gráfica Popular (People's Graphic Workshop), "I learned how you use your art for the service of people, struggling people, to whom only realism is meaningful." Elizabeth's art often depicted the struggle and strength of the black community. While in the People's Graphic Workshop, Elizabeth learned how to create lithographs, which is a printmaking technique. Her artwork would combine both African American and Mexican influences. In 1962, she became a Mexican citizen.

During her career, she created black expressionistic artwork that was political. She etched realistic portraits such as *Sharecropper* (1952), which depicted working people, and lithographs such as *Negro es bello* (*Black is beautiful*/1968), which celebrated blackness. Throughout her career, Elizabeth also created stylized, geometric sculptures that showed African American figures in a modern way. She often created images from the black power movement, like her sculpture *Homage to My Young Black Sisters* (1968).

During the second half of her life, major museums and galleries around the world celebrated Elizabeth's work. In her old age, she split her time between New York and Cuernavaca, Mexico. She continued to create art for the people well into her nineties.

IN 2009, SHE WAS HONORED AT THE NAACP IMAGE AWARDS.

SHE TAUGHT IN MEXICO CITY AT THE NATIONAL SCHOOL OF FINE ARTS FROM 1958 TO 1975.

CREATED *INVISIBLE MAN: A MEMORIAL TO RALPH ELLISON* (2003), A 15-FOOT BRONZE MEMORIAL TO THE AUTHOR, LOCATED IN RIVERSIDE PARK IN MANHATTAN.

ART · TOOLS

Whether you are designing a building, welding a sculpture, or painting the scenery, an artist needs the right tools! Artists use everything from the most expensive oil paints to trash found on the street to make their work. Here are some classic supplies an artist might use to create an amazing composition.

- EASEL
- OIL PAINT
- ERASER
- GOUACHE
- PASTELS
- SPRAY PAINT
- GRAPHITE PENCILS (SOFT, HB, HARD)
- PALETTE
- CHARCOAL
- RAG
- COLORED PENCILS
- PENCIL SHARPENER
- ACRYLIC PAINT
- PALETTE KNIFE
- CONTÉ CRAYONS
- PAINT THINNER
- PAINT
- CAMERA
- RULER
- FILM
- MOP BRUSH
- ANGLE BRUSH
- FAN BRUSH
- FILBERT BRUSH
- WASH BRUSH
- FLAT BRUSH
- ROUND BRUSH
- INK
- NIB
- CALLIGRAPHY PEN
- DRAWING PEN

CREATED SCULPTURES INSPIRED BY NATURE, SHAPES, AND SHADOWS.

HELPED TO ESTABLISH THE RUTH ASAWA SAN FRANCISCO SCHOOL OF THE ARTS.

AWARDED THE 1993 LIFETIME ACHIEVEMENT AWARD FROM THE WOMEN'S CAUCUS FOR THE ARTS.

"ART IS FOR EVERYONE. IT IS NOT SOMETHING THAT YOU SHOULD HAVE TO GO TO THE MUSEUMS IN ORDER TO SEE AND ENJOY." —RUTH ASAWA

RUTH ASAWA
SCULPTOR, ART ADVOCATE, AND TEACHER · (1926-2013)

Ruth Asawa was born in California in 1926. Her parents were Japanese immigrants who worked as farmers. Ruth and her siblings helped them on the farm before and after school. During World War II, Japan attacked the US military base at Pearl Harbor. The US government became paranoid of Japanese spies among civilians and, without cause, began arresting everyone of Japanese heritage. From 1942 to 1946, more than 100,000 Japanese Americans were held unjustly in internment camps, including sixteen-year-old Ruth and her family. Her father was placed in a separate camp, and she did not see him again until 1948. In the California internment camp where Ruth and her family were detained, there were several artists who had worked for The Walt Disney Studios, and Ruth would pass the time drawing with them.

After the war ended, Ruth attended Black Mountain College in North Carolina from 1946 through 1949. She was inspired by her teachers, who included artist Willem de Kooning and choreographer Merce Cunningham. At Black Mountain she also met architect Albert Lanier. They fell in love, married, and moved to San Francisco in 1949. Ruth started making art in her home studio while raising six children.

In the 1950s, Ruth began making her famous hanging-wire sculptures. She described her work as "a woven mesh not unlike medieval mail. A continuous piece of wire, forms envelop inner forms, yet all forms are visible (transparent). The shadow will reveal an exact image of the object." Ruth showed her work throughout the San Francisco Bay Area. Her sculptures were a huge hit, and her work was accepted into the prestigious Whitney Museum's annual exhibition and the 1955 São Paulo Art Biennial.

In 1968, Ruth was appointed to the San Francisco Arts Commission. That same year, she cofounded the Alvarado Arts Workshop for children, which became a model for art programs throughout the Untied States. Ruth's educational approach was "Learn something. Apply it. Pass it on so it is not forgotten." In 1982, she was instrumental in the creation of the Ruth Asawa San Francisco School of the Arts. Ruth continued her public outreach into her late eighties and continued to create art up until her death. As Ruth once said, "Sculpture is like farming. If you just keep at it, you can get quite a lot done."

IN 1968, SHE CREATED HER FIRST REPRESENTATIONAL WORK— A MERMAID FOUNTAIN—FOR SAN FRANCISCO'S GHIRARDELLI SQUARE.

AS A KID, RUTH AND HER SIX SIBLINGS WOULD HELP WITH THE FARMWORK.

WHILE SWEEPING THE BARN, SHE WOULD DRAW SHAPES, WHICH RESEMBLED HER FUTURE SCULPTURES, IN THE DIRT.

ALSO WORKED IN PAPER ORIGAMI, AND MANY OF THOSE PIECES WERE TURNED INTO LARGE BRONZE PUBLIC SCULPTURES THROUGHOUT SAN FRANCISCO.

WHEN HER ART OUTREACH PROGRAMS HAD NO FUNDING, RUTH WOULD MAKE BAKER'S CLAY OUT OF FLOUR, SALT, AND WATER FOR HER STUDENTS.

THE CONTINUOUS WEAVE IN HER SCULPTURES WAS INSPIRED BY BASKET WEAVING SHE SAW ON A TRIP TO MEXICO.

ONE OF THE FIRST BLACK WOMEN TO ESTABLISH HER OWN ARCHITECTURE FIRM.

FIRST AFRICAN AMERICAN FEMALE ARCHITECT LICENSED IN NEW YORK AND CALIFORNIA.

FIRST BLACK FEMALE FELLOW OF THE AIA.

"IN ARCHITECTURE, I HAD ABSOLUTELY NO ROLE MODEL. I'M HAPPY TODAY TO BE A ROLE MODEL FOR OTHERS THAT FOLLOW." —NORMA SKLAREK

NORMA SKLAREK
ARCHITECT · (1926-2012)

Norma Sklarek was born in Harlem in 1926. In 1950, she graduated from Columbia University's architecture school. The architecture exam in New York was a difficult four-day test, but Norma passed it on her first attempt, and, in 1954, she officially became the first black female licensed architect in the state. She would go on to accomplish many more historical firsts throughout her career.

In 1955, Norma was offered a job at prestigious architecture firm Skidmore, Owings & Merrill. Four years later she moved to Los Angeles to work for Gruen and Associates and, in 1962, she became the first black female architect licensed in California. In 1980, she became the first black woman to be elected a fellow of the American Institute of Architects (AIA), which is their highest designation. Five years later, Norma established her own architecture firm, called Siegel, Sklarek, and Diamond. At the time, it was the largest women-owned architecture firm in the country. In 1989, she left her firm to work on larger-scale projects at the Jerde Partnership, where she worked as a principal until she semiretired in 1992.

Norma was known for her skill in managing technically complex projects. Her buildings had state-of-the-art engineering and electrical systems, with foundations that could handle tropical storms and earthquakes—all while looking sleek and modern. Despite all of this, she felt she had to prove herself as an architect. While working on the 1980 renovation of Terminal One at LA International Airport, she recalled, "At first, the architects working on the airport were skeptical because a female was in charge of the project. But a number of projects were going on there at the time and mine was the only one on schedule."

Norma didn't just create a path for her own success, she brought others with her. Throughout Norma's career, she taught classes at multiple universities, and would tutor students to help them pass their licensing exams. It was important for her to be an available role model for other young black women going into architecture. Norma chaired the AIA National Ethics Council to fight against discrimination in her field. Norma Sklarek passed away in 2012 and has gone down in history as a pioneer who has been called the "Rosa Parks of architecture."

AIA — Norma received the AIA's Whitney M. Young Jr. Award in 2008.

Her father was a doctor, and her mother was a seamstress.

Howard University established an architectural scholarship in her name.

Other major projects include the Downtown Plaza in Sacramento, the Queens Fashion Mall in New York, and the Fox Plaza in San Francisco.

Some of her major projects in Los Angeles include the Pacific Design Center, the Wilshire/LA Brea Metro Rail Station, and the Fashion Institute of Design & Merchandising.

EXPLORES THEMES OF DOTS, REPETITION, OBLITERATION, AND INFINITY IN HER ARTWORK.

HAS BEEN CALLED JAPAN'S MOST IMPORTANT LIVING ARTIST.

RECEIVED THE NATIONAL LIFETIME ACHIEVEMENT AWARD FROM THE ORDER OF THE RISING SUN IN 2006.

"OUR EARTH IS ONLY ONE POLKA DOT AMONG A MILLION STARS IN THE COSMOS. POLKA DOTS ARE A WAY TO INFINITY. WHEN WE OBLITERATE NATURE AND OUR BODIES WITH POLKA DOTS, WE BECOME PART OF THE UNITY OF OUR ENVIRONMENT." —YAYOI KUSAMA

YAYOI KUSAMA
SCULPTOR, INSTALLATION ARTIST, PAINTER, AND PERFORMANCE ARTIST (1929–)

Yayoi Kusama sits painting polka dots, wearing a dress with printed polka dots, in a studio covered in polka-dotted canvases. Kusama has become iconic for her dots, but they are more than just a pattern for her. She has suffered from anxiety attacks and hallucinations her whole life; these often involve the world turning into dots that she becomes engulfed in. She has turned her illness into inspiration.

Kusama was born in 1929 in Matsumoto, Japan. As a child, she was always drawing and wanted to become a professional artist. Her mother discouraged Kusama from pursuing art and would even tear up her drawings. But in 1948, Kusama managed to convince her parents to let her study painting in Kyoto. In 1957, she moved to the United States for the freedom to follow her dreams.

While living as a struggling artist in New York, Kusama began to paint her famous *Infinity Nets* series. As seen in the painting *No. F* (1959), these paintings are made of seemingly endless circles that cover the entire canvas. At the time, pop artists such as Andy Warhol were dominating the American art scene. Kusama's creations fit right in with this bright and fun pop art, but hers were more personal. Throughout the 1960s, Kusama created "happenings" (which were like art parties), where she would cover canvases, people, and even entire rooms with polka dots. In 1965, she began creating her *Infinity Mirrored Rooms*, which she filled with polka-dotted objects or hanging lights. The mirrors reflected endlessly into each other, "obliterating" the viewer's sense of space. Her work was featured at major galleries, including the MoMA.

In 1973, Kusama's health continued to decline, and she moved back to Japan. She continued to work through her challenges, and in 1977, chose to reside in a psychiatric hospital. Kusama purchased a nearby studio to create her art. For her, artwork is medicine: "I fight pain, anxiety, and fear every day, and the only method I have found that relieves my illness is to keep creating art." For almost the past forty years, Yayoi Kusama has spent every day from 9:00 a.m. to 6:00 p.m. in her studio, creating hundreds of paintings, collaborating with major fashion houses, and designing installations. Her art exhibits continue to be visited by record-breaking crowds all over the world.

SHE DREW PUMPKINS AS A KID. SHE LOVES THEIR SHAPE AND HAS INCORPORATED THEM INTO MANY PIECES, INCLUDING *ALL THE ETERNAL LOVE I HAVE FOR THE PUMPKINS* (2016).

HAS MULTIPLE INFINITY ROOMS ON PERMANENT DISPLAY, INCLUDING *INFINITY MIRRORED ROOM—THE SOULS OF MILLIONS OF LIGHT YEARS AWAY* (2013) AT THE BROAD IN LOS ANGELES.

ESTABLISHED THE KUSAMA FASHION COMPANY IN 1968 AND HAS COLLABORATED WITH LANCÔME, MARC JACOBS, AND LOUIS VUITTON.

IN 2017, THE YAYOI KUSAMA MUSEUM OPENED IN TOKYO.

CORRESPONDED WITH GEORGIA O'KEEFFE BEFORE MOVING TO THE US.

LEADER IN THE ACTIVIST MOVEMENT FOR MORE REPRESENTATION IN NEW YORK MUSEUMS.

COMBINES STORYTELLING, PAINTING, AND FIBER ARTS TO CREATE NARRATIVE QUILTS.

HAS WRITTEN AND ILLUSTRATED MANY CHILDREN'S BOOKS.

"YOU CAN'T SIT AROUND WAITING FOR SOMEONE ELSE TO SAY WHO YOU ARE. YOU NEED TO WRITE IT AND PAINT IT AND DO IT! THAT'S WHERE THE ART COMES FROM. IT'S A VISUAL IMAGE OF WHO YOU ARE. THAT'S THE POWER OF BEING AN ARTIST!" —FAITH RINGGOLD

FAITH RINGGOLD
PAINTER, FIBER ARTIST, EDUCATOR, AND ACTIVIST (1930-)

Faith Ringgold was born in 1930 in Harlem. She loved growing up there and recalls that her childhood was filled with art. Her mother was a fashion designer and seamstress, and Faith was always drawing and making things. She enrolled at the City College of New York and graduated with a degree in art education in 1955. While teaching art in the city, she completed her master's degree in 1959.

In the late 1960s and 1970s, Faith became a leader in the movement to have more black and female artists featured in New York's contemporary museums. Women made up only 2 percent of the Whitney Museum's prestigious annual show. The Whitney Annual (which became a biennial in 1973) showed contemporary artists and, like the Paris salons of the early 20th century, being featured there could make an artist's career. Faith turned her focus to this women's issue and helped to organize a protest to demand more representation. When considering what the protest's demand for representation would be, Faith's teenage daughter, Michelle, boldly suggested "50 percent!" Faith and a group of women took to the streets of New York to protest, armed with whistles, signs, and painted eggs. In the next Whitney show, 20 percent of the artists represented were female. Progress had started, and finally in 2010, nearly forty years later, the Whitney Biennial would feature a majority of women.

In 1973, Faith quit teaching to focus entirely on making art. With her mother's help, she first began creating paintings, like *Echoes of Harlem* (1980), which included fabric borders with colorful embroidery, beads, and fringe. Then, in 1983, she created her first storytelling quilt, where she wrote on the canvas. In her first story quilt, called *Who's Afraid of Aunt Jemima?* (1983), Faith retold the story of the pancake-syrup mascot, Aunt Jemima, as a successful and fabulous businesswoman. Many of her quilts were turned into illustrated children's books, like *Tar Beach* (1991) and *Dinner at Aunt Connie's House* (1993).

Faith has become known for her artwork, which combines stories, fabric, and painted illustrations. Her work has been shown in many major museums throughout the United States, including in the 1985 Whitney Biennial. She continues to work, teach, and speak about the power of her craft and the importance of representation in the arts.

RECIPIENT OF THE NATIONAL ENDOWMENT FOR THE ARTS AWARDS IN SCULPTURE (1978) AND PAINTING (1989).

HER PAINTINGS WITH FABRIC BORDERS WERE INSPIRED BY TIBETAN THANGKAS.

HER WILT DOLL WAS SEVEN FEET AND THREE INCHES TALL

FAITH MADE FABRIC DOLLS AND SOFT SCULPTURE THAT SHE USED IN PERFORMANCE ART PIECES.

we flew over the bridge

WHEN HER MEMOIR KEPT GETTING REJECTED BY PUBLISHERS, SHE BEGAN WRITING HER STORY ON HER ARTWORK TO GET IT OUT THERE. SHE FINALLY PUBLISHED HER MEMOIR IN 1995.

IN 1971, SHE COFOUNDED A GROUP FOR AFRICAN AMERICAN FEMALE ARTISTS CALLED "WHERE WE AT."

COLLABORATED WITH HER HUSBAND, CHRISTO, TO CREATE LARGE-SCALE INSTALLATIONS ALL OVER THE WORLD.

WRAPPED MAJOR BUILDINGS, ENTIRE LANDMARKS, MOUNTAINS, AND COASTLINES WITH FABRIC.

"WE WANT TO CREATE WORKS OF ART OF JOY AND BEAUTY, WHICH WE WILL BUILD BECAUSE WE BELIEVE IT WILL BE BEAUTIFUL. THE ONLY WAY TO SEE IT IS TO BUILD IT. LIKE EVERY ARTIST, EVERY TRUE ARTIST, WE CREATE THEM FOR US." —JEANNE-CLAUDE DENAT DE GUILLEBON

JEANNE-CLAUDE DENAT DE GUILLEBON

ENVIRONMENTAL ARTIST · (1935-2009)

Jeanne-Claude Denat de Guillebon was born in 1935 in Casablanca, Morocco, while her father was stationed there as part of the French army. Jeanne-Claude met Christo Vladimirov Javacheff in 1958 when he painted her mother's portrait. The two fell in love and became partners in life and art. In 1961, Christo and Jeanne-Claude collaborated on their first project, *Stacked Oil Barrels and Dockside Packages*. Following that project, they created their first monumental work called *The Iron Curtain* (1961-62), an entire wall of oil barrels. In 1964, they moved to New York City.

Jeanne-Claude and Christo wanted to transform the world using colorful fabric. They wrapped buildings, valleys, and even entire islands throughout their career. From 1968 through 1969 they covered the coastline of Sydney, Australia, in 1 million square feet of fabric, calling the installation *Wrapped Coast*. Although this installation took about one year to build, it was only on display for ten weeks, then removed without a trace. Between 1972 and 1976, they created *Running Fence*, a giant 24.5-mile-long "fence" of waving fabric that ran through Northern California—it was up for only two weeks. Their work seemed impossible, magical, and ridiculous all at the same time.

Between 1980 and 1983, they wrapped the edges of eleven islands near Miami with 6.5 million square feet of bright pink fabric. The piece was simply called *Surrounded Islands* and was on display for two weeks. In 2005, they completed *The Gates* in New York's Central Park, which they began working on in 1979. It consisted of 7,503 gates of golden hanging fabric. Their massive environmental art exists only for a brief moment in time before they are dismantled, and all of the materials are recycled. Jean-Claude believed this gave their work even more value, calling it "the quality of love and tenderness that we human beings have for what does not last."

Over the fifty-one years they were together, the two artists were inseparable. Together, they directed a team of assistants to implement their large projects, often problem-solving on site. Four years after the completion of *The Gates*, Jeanne-Claude passed away. Today, Christo continues their work, implementing some of their most fantastical ideas.

THE UMBRELLAS (1984-91) WAS A SERIES OF LARGE-SCALE UMBRELLAS PLACED IN INLAND VALLEYS IN CALIFORNIA AND JAPAN TO COMPARE AND CONTRAST THE DIFFERENCES.

WRAPPED MANY MAJOR STRUCTURES IN FABRIC, LIKE THE PONT NEUF IN PARIS AND THE KUNSTHALLE BERN IN SWITZERLAND.

IT TOOK CHRISTO AND JEANNE-CLAUDE 25 YEARS TO GET PERMISSION TO WRAP BERLIN'S REICHSTAG BUILDING.

JEANNE-CLAUDE AND CHRISTO WERE BORN ON THE SAME EXACT DAY.

CHRISTO AND JEANNE-CLAUDE COVERED THE RIFLE GAP IN THE ROCKY MOUNTAINS WITH A GIANT ORANGE CURTAIN IN AN INSTALLATION CALLED *VALLEY CURTAIN* (1970-82).

KNOWN AS A LEADING ECLIPSE PHOTOGRAPHER.

ONE OF THE PIONEERS OF SYNTH MUSIC.

COMPOSED THE SCORE FOR THE FILMS A CLOCKWORK ORANGE, THE SHINING, AND TRON.

"A NICE BLEND OF PREDICTION AND SURPRISE SEEMS TO BE AT THE HEART OF THE BEST ART." —WENDY CARLOS

WENDY CARLOS
COMPOSER AND ECLIPSE PHOTOGRAPHER (1939-)

Wendy Carlos was born in Rhode Island in 1939. She began playing the piano at the age of six and also showed immense talent in graphic arts and science. After graduating from Brown University, Wendy earned her master's degree in music composition at Columbia. She then began working as a recording and mastering engineer at Gotham Recording Studio, where she met her lifelong friend Robert Moog. Robert had invented the Moog synthesizer, the first compact keyboard-based synth machine. Before the Moog, electronic music had been created using complicated machines the size of a living room. Wendy suggested to Robert that the Moog synthesizer should be touch sensitive, like an organ. Together, they collaborated to push the sounds of this machine. With this new type of instrument, Wendy helped to create brand-new sounds and a new genre of music.

Using the Moog synthesizer, Wendy created her masterpiece album, *Switched-On Bach* (1968), which was a reimagining of Johann Sebastian Bach's chorales and concertos. These new "far out" synthesizer sounds blew everyone's minds. In 1970, *Switched-On Bach* won three Grammy Awards and soon sold so many copies that the album went Platinum. The world now recognizes electronic music as a serious genre, thanks to Wendy's work.

Wendy was born Walter Carlos, but she always knew she was a trans woman. With the financial success of *Switched-On Bach*, Wendy could begin her transition in 1968. She was fearful of an angry backlash but, in 1979, she bravely came out in a magazine interview. Wendy was relieved by the acceptance she received, stating "The public turned out to be amazingly tolerant or, if you wish, indifferent." She recalls her time closeted, saying, "There had never been any need of this charade to have taken place. It had proven a monstrous waste of years of my life."

In 1970, Wendy began collaborating with director Stanley Kubrick to score his films, creating the musical scores for *A Clockwork Orange* (1971) and *The Shining* (1980). She also worked with Walt Disney Productions to score the original *Tron* (1982). Her music was able to elevate these movies to new heights. Wendy continued releasing albums into the 21st century. Today, she is known as the mother of electronic music and a pioneer who helped create a new art form.

AS A TEEN, SHE WON THE WESTINGHOUSE SCIENCE FAIR SCHOLARSHIP FOR HER HOME-BUILT COMPUTER.

SHE LOVES CATS AND LOVES DRAWING HER PETS.

HER ECLIPSE PHOTOGRAPHY HAS BEEN USED BY NASA AND HAS BEEN ON THE COVER OF SKY & TELESCOPE MAGAZINE.

HER ECLIPSE PHOTOGRAPHY INSPIRED HER ALBUM *DIGITAL MOONSCAPES* (1984).

HAS STUDIED COLOR THEORY AND THE SCIENCE OF COLOR.

HER ECLIPSE PHOTOS CAPTURE THE SUN'S BRIGHT CORONA BEHIND THE DARK SPHERE OF THE MOON.

RECEIVED THE AIGA MEDAL IN 2001.

INDUCTED INTO THE ART DIRECTORS CLUB HALL OF FAME IN 1998.

FIRST FEMALE PRINCIPAL OF THE PRESTIGIOUS DESIGN FIRM PENTAGRAM.

"YOU HAVE TO BE IN A STATE OF PLAY TO DESIGN. IF YOU'RE NOT IN A STATE OF PLAY, YOU CAN'T MAKE ANYTHING." —PAULA SCHER

¡?¡? PAULA SCHER ¡?¡?
GRAPHIC DESIGNER (1948-)

SHE WAS PRESIDENT OF THE NEW YORK AIGA CHAPTER FROM 1998 TO 2000.

HER ALBUM COVERS RECEIVED FOUR GRAMMY AWARD NOMINATIONS.

THE PUBLIC THEATER WON THE PRESTIGIOUS BEACON AWARD FOR INTEGRATED CORPORATE DESIGN STRATEGY.

Paula Scher was born in 1948 in Washington, DC. In high school, she felt like she didn't fit in, but drawing made her happy, and as an artist, she knew she belonged. She enrolled at the Tyler School of Art, and was introduced to the art of typography. In their graphic design program, she learned how fonts could set the tone and mood of a word, even before it's read, and that each letter form—with its weight, proportion, serif, and shape—references a certain time and place in history. As Paula observed, "Type has spirit. Type doesn't have to be this clean mechanical thing that is simply doing its job. It can be this marvelous thing to engage with." In 1970, Paula graduated with a Bachelor of Fine Arts from Tyler. In 1972, she got a job designing album covers for CBS records. Over a decade, she designed covers for more than 150 albums, many of which featured expressive typography.

In 1984, she cofounded Koppel & Scher design studio, and in 1991, she joined Pentagram design agency. Paula recognized that her best work came when she was in a "state of play" while designing. In 1994, she began consulting for a dream client, The Public Theater in New York City. In full "play" mode, inspired by graffiti and the city itself, Paula combined different weights of type to create the theater's logo. The following year, she created the promotional campaign and posters for the show *Bring in 'da Noise, Bring in 'da Funk*. The words moved with the dancers and emphasized the music of the show. For over twenty years, Paula would continue to perfect the visual identity of The Public Theater and create new campaigns for their shows. Her design work for the theater has become part of the fabric of New York City.

Along with her branding work, she has produced environmental designs by literally wrapping buildings in typography. These giant letters and numbers play with color and space while also communicating important information. You can see Paula's touch on buildings such as the New Jersey Performing Arts Center and The New School in New York City.

Throughout Paula Scher's career, she has blended design and fine art, lowbrow and highbrow. Today, Paula continues to work (and play) as she problem solves for clients and creates art for herself.

SHE CREATES GIANT INFOGRAPHIC PAINTINGS. HER MAP SERIES CONSISTS OF MAPS OF THE UNITED STATES FILLED WITH DATA SUCH AS AREA CODES AND DEMOGRAPHICS.

SHE HAS CREATED LOGOS AND DESIGNS FOR THE MoMA AND FOR COMPANIES SUCH AS CITIBANK, COCA-COLA, MICROSOFT, AND TIFFANY & CO.

ABCDEFGHIJKLM

101

CREATES WORK ABOUT FORGOTTEN AND DISPLACED PEOPLE IN HISTORY.

USES IMAGERY FROM OLD PHOTOGRAPHS TO CREATE OIL PAINTINGS ABOUT MEMORY.

HER STYLE HAS BEEN CALLED "WEEPING REALISM."

"ALTOGETHER, I HOPE TO WASH MY SUBJECTS OF THEIR EXOTIC 'OTHERNESS' AND REVEAL THEM AS DIGNIFIED, EVEN MYTHIC FIGURES ON THE GRANDER SCALE OF HISTORY PAINTING. I AM LOOKING FOR THE MYTHIC POSE BENEATH THE HISTORICAL FIGURE— AND THE PAINTING BENEATH THE PHOTOGRAPH." —HUNG LIU

HUNG LIU
PAINTER AND INSTALLATION ARTIST · (1948–)

SHE HAS TWICE RECEIVED NATIONAL ENDOWMENT FOR THE ARTS FELLOWSHIPS.

HER SERIES *AMERICAN EXODUS* USES PHOTOGRAPHS TAKEN BY DOROTHEA LANGE OF THE DUST BOWL.

PROFESSOR EMERITA OF PAINTING AT MILLS COLLEGE IN OAKLAND, CALIFORNIA, WHERE SHE TAUGHT FROM 1990 TO 2014.

Hung Liu was born in the Republic of China in 1948. A year after her birth, the communist party of Mao Zedong came to power, and in 1966, the Cultural Revolution began and the country was "purged" of any Western or non-communist influences. Over the next ten years, more than a million people were displaced, arbitrarily imprisoned, or even executed for expressing ideas that were not in line with Mao. During this time, many historic Chinese artifacts and buildings were destroyed in an attempt to rewrite history. All of these events had a great impact on Hung Liu, who would later create artwork that "[looked] at the way history plays out and how history is written by the winners."

As part of the Cultural Revolution's re-education program, Hung Liu was sent to a small village to work in the rice and wheat fields for four years. In her spare time, she photographed and sketched many of the local farmers. After schools reopened in 1972, Hung Liu studied art at the Beijing Teacher's College, where she trained to paint in the socialist realist style. In 1981, she completed her master's degree in mural painting at the Central Academy of Fine Arts and her portfolio was accepted into the graduate program at the University of California, San Diego. In 1984, with just $20 and two suitcases, Liu moved to the United States.

In 1991, Hung Liu took a trip back to China and discovered old photographs of child street performers, farmers, female laborers, refugees, and others. Inspired, these photos became the subjects of Hung Liu's oil paintings. She has become known for combining the photos of displaced people with imagery from traditional Chinese paintings, like traditional floral and pottery motifs. Liu has created dozens of painting series exploring these themes, including the series called *Women At Work*. Her paintings are covered with dripping layers of paint washes and linseed oil to "preserve and destroy the image" and "to give the feel of distant memory." In 2015, Hung Liu had a retrospective, called Summoning Ghosts, at Oakland Museum of California. After seeing it, a critic from the *Wall Street Journal* called her "the greatest Chinese painter in the US." Hung Liu continues to be inspired by photographs of displaced and forgotten people. Her work makes the viewer reflect on how memories shape our shared history.

SHE ALSO USES PHOTOGRAPHS FROM HER OWN LIFE, LIKE IN HER SELF-PORTRAIT PAINTED CUTOUT CALLED *AVANT-GARDE* (1993).

SHE ALSO HAS CREATED INSTALLATION ART SUCH AS *JIU JIN SHAN* (OLD GOLD MOUNTAIN/1994), A MOUND OF 200,000 FORTUNE COOKIES ON TOP OF TRAIN TRACKS.

103

CONSIDERED ONE OF THE MOST IMPORTANT ARCHITECTS OF THE 21ST CENTURY.

IN 2004, SHE BECAME THE FIRST WOMAN TO WIN THE PRITZKER ARCHITECTURE PRIZE.

WON THE UK'S STIRLING PRIZE IN 2010 AND 2011.

"THERE ARE 360 DEGREES, SO WHY STICK TO ONE?" —ZAHA HADID

ZAHA HADID
ARCHITECT · (1950-2016)

Zaha Hadid was born in Baghdad, Iraq, in 1950. Her father was the head of the progressive party that fought for secularism and democracy in Iraq. During her childhood, Baghdad was a diverse cosmopolitan center, and Zaha attended a French-speaking, private Catholic school. In 1972, she moved to London to study at the Architectural Association. After graduating she began working for the Office for Metropolitan Architecture in Rotterdam, and three years later, she opened her own firm in London. She would often paint and draw her designs, and many people thought they were too ambitious, jagged, and avant-garde to be realized in real space. But Zaha was just ahead of her time.

With the help of new computer programs, Zaha was finally able to turn her "impossible" concepts into real buildings, and in 1994, her first building—a small fire station in Germany—was constructed. Zaha would turn her commissions, no matter how small, into pieces of art. When she was commissioned to build the Rosenthal Center for Contemporary Art in Cincinnati, many would have considered it a relatively small job. When Zaha completed the project in 2003, the *New York Times* called it "the most important American building to be completed since the end of the Cold War."

Zaha expanded her design firm to 400 employees; in most firms, employing 25 people is considered large! She became famous for her fluid modern spaces that twist and turn in unexpected ways. In 2004, she became the first woman to win the Pritzker Architecture Prize, which is considered the Nobel Prize for architecture. Her firm has built structures all over the world, including the Bridge Pavilion in Zaragoza, Spain (2005-08), the Guangzhou Opera House in China (2003-10), and the Heydar Aliyev Center in Baku, Azerbaijan (2007-12). The National Museum of 21st-Century Arts (MAXXI) in Rome (1998-2010) won her the 2010 Stirling Prize.

In 2016, while Zaha was overseeing the construction of her skyscraper called the Scorpion Tower in Miami, she became ill and passed away at the age of sixty-five. Today, she is remembered as one of history's most influential architects, and her designs continue to be built all over the world.

APPOINTED COMMANDER OF THE ORDER OF THE BRITISH EMPIRE IN 2002 AND RECEIVED THE TITLE OF DAME IN 2012.

DESIGNED THE AQUATIC CENTER FOR THE 2012 LONDON OLYMPICS.

HER ARCHITECTURE PARTNER, PATRIK SCHUMACHER, ENCOURAGED ZAHA TO START WORKING WITH COMPUTER PROGRAMS TO TURN HER MOST FAR-OUT IDEAS INTO REALITY.

MANY OF HER BUILDINGS HAVE BEEN COMPLETED AFTER HER DEATH, INCLUDING THE 520 WEST 28TH STREET, NYC CONDOS, ALSO CALLED THE ZAHA HADID BUILDING.

WHEN ASKED ABOUT SEXISM IN HER INDUSTRY SHE REPLIED...

"THERE IS STILL A STIGMA AGAINST WOMEN. IT HAS CHANGED A LOT—30 YEARS AGO PEOPLE THOUGHT WOMEN COULDN'T MAKE A BUILDING. THAT IDEA HAS NOW GONE."

CREATES ART OUT OF FOUND AND DISCARDED MATERIALS.

USES HER WORK TO HIGHLIGHT ENVIRONMENTAL, SOCIAL, AND CULTURAL ISSUES.

"MY INTENTION IS TO TRANSLATE MATERIALS INTO IMAGERY THAT WILL STIMULATE PEOPLE TO CONSIDER THEMSELVES AS A PART OF THEIR ENVIRONMENT, AS ONE PIECE OF A LARGER WHOLE." —CHAKAIA BOOKER

CHAKAIA BOOKER
SCULPTOR AND INSTALLATION ARTIST · (1953-)

HAS HAD A SOLO SHOW AT THE NATIONAL MUSEUM OF WOMEN IN THE ARTS AND THE STORM KING ART CENTER.

CHAKAIA GREW UP SEEING HER AUNTS, GRANDMA, AND SISTER SEWING THEIR OWN GARMENTS.

EVERY TIME SHE WORKS WITH A NEW MATERIAL, SHE MAKES A NEW WEARABLE ART PIECE.

Chakaia Booker's large sculptures are dark, textural, and smell strongly. She cuts, bends, shaves, and folds old tires to create abstract forms. Chakaia's work touches on many issues, from commentary on environmental problems and the Industrial Revolution to diversity and the history of slavery. Sometimes her work is about the tires themselves, as wheels are a vehicle for freedom. Chakaia doesn't like to overexplain her work and lets viewers decide what it means to them.

Chakaia was born in New Jersey in 1953. In 1976, she graduated from Rutgers University with a degree in sociology. When a friend gave her a handmade coil pot as a gift, Chakaia found her true calling! She loved the texture and messy glaze on her gift so much that she began learning how to make her own ceramics. Chakaia experimented with weaving, painting, and layering broken pieces of ceramics to make sculptures. Soon she was creating large-scale sculptures and wearable pieces of art out of found objects and woven baskets. Wearable art is when sculpture meets fashion. Chakaia makes most of her own clothes and headdresses and likes to "sculpt herself" before heading to the studio.

The act of recycling discarded materials would become the foundation of her work, and nothing was off-limits, including dish racks, fruit, bones, and bottle caps. While living in New York City in the 1980s, Chakaia found her favorite material—tires salvaged from abandoned cars.

In 1993, she received a Master of Fine Arts from the City College of New York. In 1996, her piece *Repugnant Rapunzel* was featured in the 20th-century-culture exhibition at the White House. In 2000, she had two pieces featured at the Whitney Biennial: *Echoes in Black* (1997) and *It's So Hard to Be Green* (2000). These two sculptures made from tires are about the sacrifices we have made to become an industrialized society. In 2005, Chakaia received a fellowship from the Guggenheim Foundation. Her tire sculptures have been exhibited at the Smithsonian Institution and are in the collections of many museums, including the MET in New York. She plans never to retire and to continue making art out of her favorite material—found tires!

DOES TAI CHI EVERY DAY.

HAS CREATED LARGE OUTDOOR PUBLIC SCULPTURES SUCH AS *PASS THE BUCK* (2008), *TAKE OUT* (2008), AND *SHAPE SHIFTER* (2012).

IN 2010, SHE WON THE PRITZKER ARCHITECTURE PRIZE WITH RYUE NISHIZAWA.

COFOUNDER OF SANAA, ONE OF THE MOST PRESTIGIOUS ARCHITECTURE FIRMS IN THE WORLD.

HAS DESIGNED PROJECTS ALL OVER THE WORLD.

"I HAVE A DREAM THAT ARCHITECTURE CAN BRING SOMETHING TO CONTEMPORARY SOCIETY. ARCHITECTURE IS HOW PEOPLE MEET IN SPACE." —KAZUYO SEJIMA

KAZUYO SEJIMA
ARCHITECT · (1956-)

Kazuyo Sejima creates buildings with a light touch. Her structures never completely separate the outside from the inside, with giant sun-filled windows, geometric shapes, and fluid open spaces. She is known for her white spaces, made of reflective metal, marble, and glass. Her buildings are made to be explored, to sit in and to watch nature, and to meet new friends. Sejima believes that architecture is more than just constructing landmarks, it is about the human experience, creating places for people to connect. She doesn't even consider a building complete until others start using it.

Sejima was born in Ibaraki prefecture, Japan, in 1956. She graduated from Japan Women's University in 1981 with a master's degree in architecture and was then employed by renowned architect Toyo Ito. In 1987, Sejima founded her own firm in Tokyo, Kazuyo Sejima & Associates. By 1992, she had been named young architect of the year for her design for the Saishunkan Seiyaku Women's Dormitory in Kumamoto (1990-91). This building had Sejima's signature brightness, with its light-filled white spaces and large open-air common spaces, where students could hang out and study. Sejima's business continued to grow, and in 1995, she partnered with architect Ryue Nishizawa to found the firm Sejima and Nishizawa and Associates (SANAA). This enabled them to tackle larger and more complex projects.

In the beginning of their partnership, most of SANAA's projects were based in Japan. They designed museums such as the O-Museum (1995-99) in Nagano and the 21st-Century Museum of Contemporary Art in Kanazawa (1999-2004). These spaces allowed visitors to create their own path through the museum. In the early 2000s, Sejima and Nishizawa began one of their first major works abroad; an iconic cube design of the Zollverein School of Management and Design (2003-06) in Germany. They went on to design many more iconic landmarks, like the asymmetrical New Museum in New York City (2003-07) and the undulating Rolex Learning Center in Switzerland (2004-10).

In 2010, together, Sejima and Nishizawa won the Pritzker Prize, which is considered the Nobel Prize in architecture. SANAA continues to be one of the most prestigious and important architecture firms in the world.

IN 2010, SEJIMA BECAME THE FIRST WOMAN TO CURATE THE VENICE ARCHITECTURE BIENNALE.

SANAA DESIGNED THE NEW BRANCH OF THE LOUVRE IN LENS, FRANCE.

BOTH SEJIMA AND NISHIZAWA HAD THEIR OWN FIRMS FOR SMALLER-SCALE PROJECTS.

SEJIMA HAS TAUGHT AT PRINCETON UNIVERSITY, THE POLYTECHNIQUE DE LAUSANNE, TAMA ART UNIVERSITY, AND KEIO UNIVERSITY.

SANAA'S DESIGN OF THE NEW MUSEUM IS SIX ASYMMETRICAL BOXES, BASED ON THE PROPORTIONS OF THE BUILDINGS AROUND THEM.

USES FILM AND PHOTOGRAPHY TO TALK ABOUT POLITICAL ISSUES AND FEMINISM.

DIRECTED THE FILMS WOMEN WITHOUT MEN AND LOOKING FOR OUM KULTHUM.

HER PHOTOGRAPHY AND VIDEO WORK HAVE BEEN FEATURED AT THE WHITNEY, THE GUGGENHEIM, AND MANY OTHER INTERNATIONALLY ACCLAIMED MUSEUMS.

"[ARTISTS] ARE THERE TO INSPIRE, TO PROVOKE, TO MOBILIZE, TO BRING HOPE TO OUR PEOPLE. WE ARE THE REPORTERS OF OUR PEOPLE, AND ARE COMMUNICATORS TO THE OUTSIDE WORLD. ART IS OUR WEAPON. CULTURE IS A FORM OF RESISTANCE." —SHIRIN NESHAT

SHIRIN NESHAT
PHOTOGRAPHER AND FILM DIRECTOR · (1957–)

Shirin Neshat was born in 1957 in Qazvin, Iran, in a "very warm, supportive Muslim family environment." At the time, Iran was a secular country. In 1974, at seventeen, she moved to the United States to get her art degree at the University of California, Berkeley. While she was in the United States, the 1979 Islamic revolution happened in Iran. The Persian monarchy was overthrown and the government was replaced by an Islamic Republic ruled with strict religious laws. In 1983, it became illegal for women to show any skin other than their hands, feet, and face. Meanwhile in the United States, Shirin moved to New York City and worked at the Storefront for Art and Architecture. She returned to Iran in 1990 and was shocked by how much the country had changed. She became inspired by the strength and perseverance of the women in Iran. In 1993, she began photographing herself in her chador, one of the types of veils all women were required to wear by law in Iran. This was the start of her *Women of Allah* series (1993–97), in which Shirin combines images of veiled women and words from religious texts on the parts of their bodies that they are allowed to show in public. With these pieces, she explored ideas of martyrdom, faith, and feminism.

The longer Shirin stayed in Iran, the more political her work became, but being critical of the Iranian government can lead to imprisonment or even execution. Shirin feared for her safety and left Iran in 1996. She began her work as "an artist in exile." Although she cannot make her work in Iran, she continues to tell stories of Iranian people. She strives to create art that both fights against negative stereotypes about Middle Eastern people and also talks about Iran's oppressive government. Shirin is constantly "fighting two battles on different grounds."

For six years, Shirin directed and worked on her film *Women Without Men* (2009), which is set in 1953 during Iran's foreign-backed coup. It tells the story of four women looking for freedom from oppression, while the country of Iran itself is protesting for democracy and freedom from foreign interventions. Today, Shirin is based in New York City and continues to travel the world directing films. For her, art is a powerful political tool.

THE FILM *WOMEN WITHOUT MEN* WAS BASED ON A BANNED BOOK BY SHAHRNUSH PARSIPUR, WHO SPENT 5 YEARS IN PRISON AFTER ITS PUBLICATION.

IN 1997, SHE WON THE 48TH VENICE BIENNIAL PRIZE FOR HER TWO-SCREEN VIDEO INSTALLATION CALLED *TURBULENT*.

DIRECTED THE MOVIE *LOOKING FOR OUM KULTHUM* (2017), WHICH IS ABOUT A FAMOUS EGYPTIAN SINGER.

SHIRIN WON THE SILVER LION AWARD FOR BEST DIRECTOR AT THE 66TH VENICE FILM FESTIVAL FOR THE MOVIE *WOMEN WITHOUT MEN*.

"IF IT IS POLITICAL TO REALIZE YOU HAVE A VOICE, THEN I GUESS I HAVE ALWAYS BEEN POLITICAL, I WAS BORN POLITICAL." —SOKARI DOUGLAS CAMP

SOKARI DOUGLAS CAMP
SCULPTOR (1958–)

Sculptor Sokari Douglas Camp absolutely loves working in steel. Through welding, Sokari has transformed metal into delicate flowers, patterned fabric, a dancing woman, and even a life-size bus. With this strong material, she creates beautiful, permanent pieces of art.

Sokari was born in Buguma, Nigeria, in 1958. She was raised by her brother-in-law, an anthropologist whose family was in the arts. He gave Sokari her very first paint set. At the age of eight, she began attending boarding school in England. She then studied at the Central School of Art and Design in London and received a Master of Arts degree from the Royal College of Art in 1986. After completing her studies, Sokari returned to Nigeria, where she met her husband, architect Alan Camp. Together, they moved back to England.

Sokari's sculptural work is inspired both by her time in the UK and by the strength, fashion, and spirit of the Nigerian people. Her sculptural figures are often dressed in traditional Nigerian clothing—with decorative patterns and bright colors—all made out of metal. Over the course of her career, she has exhibited all over the world.

In 2012, Sokari created the sculpture called *All the World Is Now Richer* to commemorate the abolition of slavery. She was inspired by former slave William Prescott, who, in 1937 wrote, "They will remember that we were sold but they won't remember that we were strong; they will remember that we were bought but not that we were brave." Sokari created six sculpted figures, each dressed in the clothing of a different time period, representing the history before and after emancipation. This powerful piece of art has been shown publicly at many locations, including The House of Commons in London. Sokari also uses sculpture to talk about the need to protect our planet. She wants to especially bring attention to the pollution of the Niger Delta in Nigeria. In response, Sokari has created many art pieces that use recycled oil barrels, such as the sculpture *Green Leaf Barrel* (2014).

Today, Sokari can be found in her home studio in London with a blowtorch in one hand and metal in the other, creating beautiful works of art that focus on issues she cares about.

WORKS SUCH AS *BLIND LOVE AND GRACE* (2016) REFERENCE CLASSICAL WESTERN PAINTINGS BUT FEATURE NIGERIAN FIGURES IN TRADITIONAL GARMENTS.

"I HAVE A DREAM THAT THE NIGER DELTA WILL BE CURED EVEN THOUGH IT IS DYING OF OIL POLLUTION."
—SOKARI DOUGLAS CAMP

BATTLE BUS: LIVING MEMORIAL FOR KEN SARO-WIWA (2006) IS A LIFE-SIZE SCULPTED BUS NAMED FOR THE RESPECTED ECO-ACTIVIST.

HER WORK IS IN COLLECTIONS AT THE SMITHSONIAN MUSEUM, TOKYO'S SETAGAYA ART MUSEUM, AND THE BRITISH MUSEUM.

HER WORK FOCUSES ON HISTORY, SCIENCE, CIVIL RIGHTS, AND ENVIRONMENTALISM.

DESIGNED THE VIETNAM VETERANS MEMORIAL, THE CIVIL RIGHTS MEMORIAL IN ALABAMA, AND THE WOMEN'S TABLE AT YALE UNIVERSITY.

WON THE NATIONAL MEDAL OF ARTS, THE NATION'S HIGHEST HONOR FOR ARTISTIC EXCELLENCE, IN 2009.

"I TRY TO GIVE PEOPLE A DIFFERENT WAY OF LOOKING AT THEIR SURROUNDINGS. THAT'S ART TO ME." —MAYA LIN

MAYA LIN
ARCHITECT, SCULPTOR, AND DESIGNER · (1959-)

Maya Lin was born in 1959 in Athens, Ohio. She came from an academic family and began her studies in architecture at Yale University. In 1981, there was a nationwide call for entries to design the Vietnam Veterans Memorial in Washington, DC. The Vietnam War had been very unpopular in the United States, and hundreds of thousands of young men had been drafted to fight overseas. The war ended in 1975, when the United States withdrew from Vietnam in defeat. In 1981, the war was still controversial. Maya entered the competition with her design of a simple V-shaped, reflective black stone wall that would sink into the earth. On the wall would be the names of every fallen soldier. She wanted to create a space where each visitor could reflect upon and remember the war in their own personal way. At the age of twenty-one, while still a college student, Maya won the competition!

When it was announced that Maya had designed the winning piece, there was an uproar. Her Asian heritage was met with racial slurs from politicians and the press. Some politicians criticized its unique design, wanting a more traditional monument. They proposed painting the memorial white and placing an 8-foot statue and flag on top of it. Maya defended her design in front of Congress and a room full of reporters, and her original design was built. Since 1982, millions of people have visited the memorial to mourn and remember. It is now widely beloved.

The Vietnam Veterans Memorial was just the start of Maya's career. She has created sculptures inspired by the Native American burial mounds she saw growing up in Ohio. Her *Wave Field* series features landscapes sculpted into oceanlike waves. Her many buildings, such as the Weber House (1991-93) and the Langston Hughes Library (1999), were created in response to the landscape around them. In all her work, Maya is committed to using sustainable materials and limiting the negative impact on the environment. Maya has also designed many memorials that mark complicated moments in history. She created the Civil Rights Memorial (1989) in Alabama, and The Women's Table at Yale University (1993). Maya Lin's work is not just architecture or just sculpture; instead, it's something powerful that does both. Today, she continues to push the boundaries of art and design.

IN 2016, SHE WAS AWARDED THE PRESIDENTIAL MEDAL OF FREEDOM, THE HIGHEST CIVILIAN HONOR IN THE US.

THAT'S A LOT OF ZEROS.

THE WOMEN'S TABLE AT YALE LISTS THE NUMBER OF WOMEN WHO HAVE ATTENDED YALE SINCE ITS FOUNDING IN 1701, STARTING WITH A LONG STRING OF ZEROS MARKING EACH YEAR NO WOMEN WERE ALLOWED ENTRANCE.

HER CIVIL RIGHTS MEMORIAL IS INSPIRED BY MARTIN LUTHER KING JR'S QUOTE "UNTIL JUSTICE ROLLS DOWN LIKE WATERS AND RIGHTEOUSNESS..."

THE MEMORIAL TITLED "WHAT IS MISSING" HIGHLIGHTS ANIMAL AND PLANT SPECIES THAT HAVE GONE EXTINCT AND THE DESTRUCTION OF HABITATS THROUGHOUT THE WORLD.

MORE · WOMEN · IN · ART

HELENA OF EGYPT
(LATE 4TH CENTURY B.C.E.)

Painter in ancient Alexandria known for her battle scenes.

SAHIFA BANU
(EARLY 17TH CENTURY A.D.)

Princess in the court of Jahangir and the most renowned miniature painter during the Mughal Empire of India.

MARIA MONTOYA MARTINEZ
(1887-1980)

Internationally acclaimed Native American artist known for her Pueblo-style pottery.

CLAUDE CAHUN
(1894-1954)

Photographer and writer who used costumes to explore gender identity. Challenged society's gender constructs by photographing herself dressed in clothes that were hyper-feminine, masculine, or gender-neutral.

LINA BO BARDI
(1914-1992)

Italian-born, Brazilian modernist architect and furniture and jewelry designer. One of Brazil's most important architects.

LEANORA CARRINGTON
(1917-2011)

English-born Mexican artist, painter, and writer. Part of the surrealist movement and founding member of the women's liberation movement in 1970s Mexico.

DIANE ARBUS
(1923-1971)

American photographer known for her black-and-white portraits of outcasts and marginalized people on the fringes of society.

HELEN FRANKENTHALER
(1928-2011)

American abstract expressionist and major contributor to the color field movement. Awarded a National Medal of Arts in 2001.

DEBORAH EVELYN SUSSMAN
(1931-2014)

Graphic designer and a pioneer in environmental design, who incorporated graphic arts into architecture and public spaces.

BARBARA KRUGER
(1945-)

American conceptual artist, known for her iconic black, white, and red photo collages and feminist messages.

TOSHIKO MORI
(1951-)

Japanese architect and founder of New York-based Toshiko Mori Architect, PLLC, and Vision Arc. Her modern, innovative, and eco-friendly designs have won many major AIA awards.

LUBAINA HIMID
(1954-)

British contemporary artist and curator who was appointed to the Most Excellent Order of the British Empire in June 2010 for "services to black women's art."

SUSAN KARE
(1954-)

Graphic designer who created the icons for the first Apple Macintosh computer in the 1980s and designed elements for Microsoft and IBM products.

LI CHEVALIER
(1961-)

Chinese-born French painter and installation artist whose work often features ink paintings, cellos, and dramatic lighting to create a contemplative space.

WANGECHI MUTU
(1972-)

A Kenyan-born internationally acclaimed artist whose paintings, sculptures, films, and performances deal with themes of Afrofuturism.

CONCLUSION

In this book, you have read about sculptors who have created monuments, architects who have transformed our skylines, and painters who have bared their souls. But art is not just how we express ourselves, it is also how we choose to see the world. When looking at a piece of artwork, whether it is an advertisement or an oil painting, ask yourself what is the artist's intent, what purpose does this work serve, and what story does it tell?

Throughout history, female artists have pushed boundaries, created important works, and inspired the world. Many of these artists had to struggle against sexism, classism, racism, or other obstacles to get their work seen and taken seriously. Now we can include these women in their rightful place in art history and celebrate their contributions. Let us honor their legacy by continuing to create. Build what you see in your wildest dreams! Express yourself by creating something new! Share your ideas with the world! And go out there and make your own masterpiece!

SOURCES

Researching this book was so much fun. I used all sorts of sources: gallery archives, interviews, lectures, museum articles, books, films, and the internet. If you are interested in learning more about these women (and you definitely should!), here are some of the sources I consulted—they are a great place to start.

If you would like to know more specific sources for each of the women in my book, visit my website at rachelignotofskydesign.com/women-in-art-resources.

BOOKS

Brown, Rebecca M., and Deborah S. Hutton. *A Companion to Asian Art and Architecture (Blackwell Companions to Art History).* Chichester, UK: Wiley-Blackwell, 2015.

Chang, Kang-i Sun, and Haun Saussy. *Women Writers of Traditional China: An Anthology of Poetry and Criticism,* Stanford, CA: Stanford University Press, 2000.

Ghez, Didier. *They Drew As They Pleased,* vol. 4, *The Hidden Art of Disney's Mid-Century Era: The 1950s and 1960s.* San Francisco: Chronicle Books, 2018.

Heller, Nancy G. *Women Artists: An Illustrated History*. New York: Abbeville Press, 2003.

Hong Lee, Lily Xiao, Clara Lau, and A. D. Stefanowska, eds. *Biographical Dictionary of Chinese Women,* vol. 1, *The Qing Period, 1644-1911*. Abingdon, UK: Routledge, 2015.

Kleiner, Fred S. *Gardner's Art Through the Ages: A Global History*, 14th ed. Boston: Cengage Learning, 2013.

———. *Gardner's Art Through the Ages: Backpack Edition, Book F: Non-Western Art Since 1300*, 15th ed. Boston: Cengage Learning, 2015.

Lightman, Marjorie, and Benjamin Lightman. *A to Z of Ancient Greek and Roman Women*. New York: Facts on File, 2007.

Mathews, Nancy Mowll. *Mary Cassatt: A Life*. New York: Villard Books, 1994.

Penrose, Antony. *The Lives of Lee Miller*. New York: Thames & Hudson, 1995.

Polan, Brenda, and Roger Tredre. *The Great Fashion Designers*. Oxford, UK: Berg Publishers, 2009.

Seaman, Donna. *Identity Unknown: Rediscovering Seven American Women Artists*, New York: Bloomsbury USA, 2017.

Stokes, Simon. *Art and Copyright*. Oxford, UK: Hart Publishing, 2012.

Strickland, Carol. *The Annotated Mona Lisa: A Crash Course in Art History from Prehistoric to the Present (Annotated Series)*, 3rd ed. Kansas City, MO: Andrews McMeel Publishing, 2018.

Weidemann, Christiane. *50 Women Artists You Should Know*. New York: Prestel, 2017.

STATISTICS

Anagnos, Christine, Veronica Treviño, Zannie Giraud Voss, and Alison D Wade. *The Ongoing Gender Gap in Art Museum Directorships*. Association of Art Museum Directors. aamd.org/sites/default/files/document/AAMD%20NCAR%20Gender%20Gap%202017.pdf (accessed December 18, 2018).

Do women have to be naked to get into the Met. Museum? Guerrilla Girls. guerrillagirls.com/naked-through-the-ages (accessed December 18, 2018).

WEBSITES

American Institute of Architects: www.aia.org

American Institute of Architects California Council: www.aiacc.org

American Institute of Graphic Arts: aiga.org

The Broad: thebroad.org

Brooklyn Museum: brooklynmuseum.org

Eames: eamesoffice.com

Encyclopedia Britannica: britannica.com

The Georgia O'Keeffe Museum: okeeffemuseum.org

Guggenheim museums and foundation: guggenheim.org

Industrial Designers Society of America: idsa.org

Makers: www.makers.com

The Metropolitan Museum of Art: metmuseum.org

The Museum of Modern Art (MoMA): moma.org

National Museum of American History, Smithsonian Institution: americanhistory.si.edu

National Museum of Women in the Arts: nmwa.org

National Visionary Leadership Project: visionaryproject.org

San Francisco Museum of Modern Art: sfmoma.org

Smithsonian American Art Museum: americanart.si.edu

Tate: tate.org.uk

Victoria and Albert Museum: vam.ac.uk

MOVIES, VIDEOS, AND LECTURES

Abstract: The Art of Design "Paula Scher: Graphic Design." Directed by Richard Press; starred Paula Scher. Netflix, February 10, 2017.

American Masters: "Dorothea Lange: Grab a Hunk of Lightning." Directed and written by Dyanna Taylor. PBS, August 29, 2014.

American Masters: "Eames: The Architect & The Painter." Produced and written by Jason Cohn. PBS, November 11, 2011.

Art in Exile. TEDWomen talk by Shirin Neshat, 2010. ted.com/talks/shirin_neshat_art_in_exile?language=en, 2010.

Good Morning America: Interview with Loïs Mailou Jones. ABC News, 1995.

Great design is serious, not solemn. TED talk by Paula Scherat, 2008. ted.com/talks/paula_scher_gets_serious?language=en, 2008.

Maya Lin: A Strong Clear Vision. Directed and written by Freida Lee Mock; starred Maya Lin. Ocean Releasing, October 1994.

No Colour Bar, Black British Art in Action. Artist's talk by Sokari Douglas Camp. youtube.com/watch?v=_yr1fztwrnU, November 26, 2017.

Tamara de Lempicka, Worldly Deco Diva. Directed by Helen Nixon; presented by Andrew Graham-Dixon. BBC Four, 2004.

Yayoi Kusama, Obsessed with Polka Dots. Tate video. youtube.com/watch?v=rRZR3nsiIeA, February 6, 2012.

ACKNOWLEDGMENTS

This book is possible because of my amazing team at Ten Speed Press. Thank you to Kaitlin Ketchum for being my all-star editor. Her support, amazing suggestions, and passion for feminism have made it possible for this series of women's history books to be published. I am grateful to copy editor Dolores York and Ten Speed managing editor Doug Ogan for making sure my poor spelling and grammar won't embarrass me. Another huge thank-you to my designer Chloe Rawlins for her talented typesetting skills, and to Dan Myers and the Ten Speed production team, who all make sure these books look so good. A big shout-out to Windy Dorresteyn, Daniel Wikey, and Lauren Kretzschmar, the marketing and publicity team whose hustle makes sure these books reach you all in the real world. I would also like to express my appreciation to Claire Posner, who manages the subsidiary rights for my work. Her hard work has allowed my books to be translated and sold all over the world.

Thank you to literally the greatest literary agent in the whole world, Monica Odom. She has helped to make every single one of my book dreams come true.

A huge thanks to the Ignotofsky family, to Aditya Voleti for his input, and to all of my dear friends who have heard me talk about this book nonstop.

All of my love goes to my husband and business partner, Thomas Mason IV, for help in fact checking, for his input and suggestions, and for making sure that I am fed. He is my ultimate cheerleader, who makes my books possible and my life wonderful.

Finally, a huge thank-you to all of the women throughout history who inspired me to become an artist (I'm looking at you, Georgia O'Keeffe). And a big thank-you to all of the faculty at Tyler School of Art's GAID program for teaching me how to critically think about design.

ABOUT THE AUTHOR

Rachel Ignotofsky is a *New York Times* bestselling author and illustrator, based in beautiful Los Angeles. She grew up in New Jersey on a healthy diet of cartoons and pudding. She graduated from Tyler School of Art's graphic design program in 2011. Rachel works for herself and spends all day and night drawing, writing, and learning as much as she can.

 Her work is inspired by history and science. She believes that illustration is a powerful tool that can make learning exciting, and she has a passion for taking dense information and making it fun and accessible. Rachel hopes to use her work to spread her message about scientific literacy and feminism.

I'M ALWAYS WRITING AND DRAWING.

CHECK OUT MY NEWEST BOOKS!

MY NEXT BOOK

VISIT:
RachelIgnotofskyDesign.com

@RACHELIGNOTOFSKY

@IGNOTOFSKY

SEE MORE OF RACHEL IGNOTOFSKY'S BOOKS AND ART!

MORE BOOKS ABOUT WOMEN'S HISTORY

BOOKS ABOUT SCIENCE

THE WONDROUS WORKINGS OF PLANET EARTH

WOMEN IN SPORTS

WOMEN IN SCIENCE

DON'T FORGET TO CHECK OUT

I LOVE SCIENCE JOURNAL

POSTCARDS • AND • PUZZLES

125

INDEX

A
Agha, Mehemed Fehmy, 71
Álvarez Bravo, Lola, 62-63
Álvarez Bravo, Manuel, 63
animation, 73
Arbus, Diane, 117
architecture, 38-39, 78-79, 90-91, 104-5, 108-9, 115, 116, 117
art
 elements and principles of, 34-35
 gender inequality and, 58-59
 power of, 6-7
 tools, 86-87
Asawa, Ruth, 88-89

B
Bach, Johann Sebastian, 99
Banu, Sahifa, 116
Blair, Lee, 73
Blair, Mary, 72-73
Bo Bardi, Lina, 116
Bonheur, Rosa, 22-23
Booker, Chakaia, 106-7
Boucard, Pierre, 55
Bourgeois, Louise, 58, 76-77
Brice, Fanny, 75

C
Cahun, Claude, 116
Cameron, Julia Margaret, 20-21
Camp, Alan, 113
Camp, Sokari Douglas, 112-13
Carlos, Wendy, 98-99
Carrington, Leandra, 116
Cassatt, Mary, 28-29
Castel, Etienne du, 13
Catlett, Elizabeth, 6, 65, 84-85
ceramics, 30-31, 116
Cézanne, Paul, 58, 83

Chase, Edna Woolman, 67
Chevalier, Li, 117
Christo, 96, 97
Civil Rights Act, 8
Clement VIII (pope), 15
collages, 45, 63, 117
Cunningham, Merce, 89

D
Dada movement, 45
Dali, Salvador, 81
de Kooning, Willem, 58, 89
Denat de Guillebon, Jeanne-Claude, 96-97
Disney, Walt, 73
Driskell, David, 65
Du Bois, W. E. B., 49

E
Eames, Charles, 79
Eames, Ray, 78-79
Ellison, Ralph, 85
environmental art, 96-97, 101

F
fashion design, 36-37
fiber arts, 94-95
films, 72-73, 79, 110-11
Fontana, Lavinia, 14-15
Frankenthaler, Helen, 117

G
Gauguin, Paul, 83
Goldwater, Robert, 77
graphic design, 70-71, 100-101, 117
Guan Daosheng, 10-11
Guerrilla Girls, 59

H
Hadid, Zaha, 104-5
Hausmann, Raoul, 45

Helena of Egypt, 8, 116
Himid, Lubaina, 117
Höch, Hannah, 44-45
Hofmann, Hans, 79
Howard, John Galen, 39

I
illuminated manuscripts, 9, 13
illustrations, 32-33, 73
industrial design, 60-61, 78-79
installation art, 77, 93, 97, 103, 106-7, 117

J
Jackson, William Henry, 31
Jacob, Isidore René, 37
Javacheff, Christo Vladimirov, 96, 97
Jeanne-Claude, 96-97
Johnson, James Weldon, 49
Jones, Loïs Mailou, 64-65

K
Kahlo, Frida, 7, 9, 63, 68-69
Kare, Susan, 117
King, Martin Luther, Jr., 85, 115
Klumpke, Anna Elizabeth, 23
Kogan, Belle, 60-61
Kruger, Barbara, 117
Kubrick, Stanley, 99
Kuffner, Raoul, 55
Kusama, Yayoi, 92-93

L
Lange, Dorothea, 50-51, 103
Lanier, Albert, 89
Le Brun, Jean-Baptiste-Pierre, 19
Lempicka, Tamara de, 54-55
Lempicki, Tadeusz, 55
Leonardo da Vinci, 58

Lewis, Mary Edmonia, 8, 26–27
Lhote, André, 55
Liebes, Dorothy, 52–53
Lin, Maya, 7, 114–15
Li of Shu, Lady, 11
Liu, Hung, 102–3

M
Madonna, 55
Marie Antoinette (queen of France), 19
Martinez, Maria Montoya, 116
Micas, Nathalie, 23
Miller, Lee, 7, 66–67
Mitchell, Joan, 58
Modigliani, Amedeo, 83
Modotti, Tina, 63
Moog, Robert, 99
Moore, Annie, 33
Morgan, Julia, 38–39
Mori, Toshiko, 117
music composition, 99
Mutu, Wangechi, 117

N
Nampeyo, 30–31
Nast, Condé, 67, 71
National Museum of Women in the Arts, 8, 14
Neshat, Shirin, 110–11
Nevelson, Charles, 57
Nevelson, Louise, 56–57
Niépce, Joseph Nicéphore, 21
Nishizawa, Ryue, 108, 109

O
O'Keeffe, Georgia, 42–43, 58, 93
Oppenheim, Méret, 80–81

P
painting, 10–11, 14–19, 22–23, 28–29, 40–43, 46–47, 54–55, 64–65, 68–69, 74–75, 82–83, 92–95, 102–3, 116, 117
Paquin, Jeanne, 36–37
Parsipur, Shahrnush, 111
Penrose, Roland, 67
photography, 7, 20–21, 50–51, 62–63, 66–67, 98–99, 110–11, 116, 117
Picasso, Pablo, 81
Pierre-Noel, Louis Vergniaud, 65
Pineles, Cipe, 70–71
Pizan, Christine de, 8, 12–13
poetry, 10–11
Potter, Beatrix, 32–33
Powers, Harriet, 24–25
Prescott, William, 113
Price, Vincent, 75
printmaking, 17, 29, 84–85

Q
quilts, 24–25

R
Ray, Man, 67, 81
Reinhardt, Ad, 71
Renzong, Emperor, 10, 11
Ringgold, Faith, 94–95
Rivera, Diego, 57, 69, 74, 75

S
Saarinen, Eero, 79
Savage, Augusta, 48–49
Scher, Paula, 100–101
Schumacher, Patrik, 105
sculpture, 8, 26–27, 49, 56–57, 76–77, 80–81, 84–85, 88–89, 93, 106–7, 112–15, 117
Sejima, Kazuyo, 108–9
Sher-Gil, Amrita, 82–83
Sirani, Elisabetta, 16–17
Sirani, Giovanni Andrea, 17
Sklarek, Norma, 90–91
Smith, Jennie, 24
Stieglitz, Alfred, 43
Streat, Thelma Johnson, 9, 74–75
surrealist movement, 81
Sussman, Deborah Evelyn, 117

T
Tarsila do Amaral, 40–41
textile design, 53, 65
Thomas, Alma, 46–47, 65
timeline, 8–9
Tubman, Harriet, 85

U
Utamaro, Kitagawa, 29

V
Valentine, Helen, 71
Vigée Le Brun, Elisabeth, 18–19

W
Warhol, Andy, 71, 93
Warne, Norman, 33
weaving, 52–53
Wedgwood, Thomas, 21
Weston, Edward, 63
Wheatley, Phillis, 85

Z
Zappi, Paolo, 15
Zhao Mengfu, 11

Dedicated to all my art teachers and professors who encouraged me as a young woman.

Copyright © 2019 by Rachel Ignotofsky

All rights reserved.
Published in the United States by Ten Speed Press, an imprint of Random House, a division of Penguin Random House LLC, New York.
tenspeed.com
randomhousebooks.com

Ten Speed Press and the Ten Speed Press colophon are registered trademarks of Penguin Random House LLC.

Originally published in hardcover by Ten Speed Press, an imprint of Random House, a division Penguin Random House LLC in 2019.

Printed in India

Design by Chloe Rawlins

10 9 8 7 6 5 4 3 2 1

2022 Paperback Boxed Set Edition